IMAGES
of America

THE LINCOLN HIGHWAY
ACROSS INDIANA

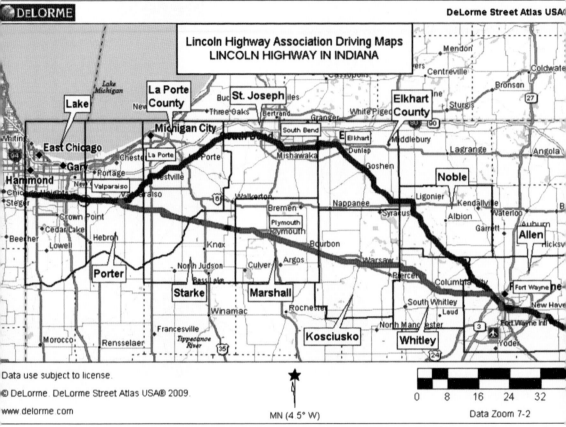

Indiana is unique in that there are two Lincoln Highway alignments across the state. The original alignment headed northwest from Fort Wayne following the old Fort Wayne to Goshen Road and included Churubusco, Ligonier, Goshen, Elkhart, Mishawaka, South Bend, New Carlisle, and La Porte. In 1926, the route was shortened to create a direct route from Fort Wayne to Valparaiso. The 1928 Lincoln Highway concrete markers were planted on this route that included Columbia City, Warsaw, and Plymouth. (Courtesy of Paul Gilger/Lincoln Highway Association.)

On the cover: The official car of the Lincoln Highway Association pauses at the Indiana-Illinois state line to take a photograph. The association actively promoted the building of the first coast-to-coast automobile road by circulating images and information about the progress of the road. The standard Lincoln Highway state line markers were made of cast iron. A few state line markers survive, but the fate of Indiana's markers is unknown. (Courtesy of the Lincoln Highway Association collection/University of Michigan.)

IMAGES
of America

THE LINCOLN HIGHWAY ACROSS INDIANA

Jan Shupert-Arick for the
Indiana Lincoln Highway Association

ARCADIA
PUBLISHING

Published by Arcadia Publishing
Charleston, South Carolina

Printed in the United States of America

Library of Congress Control Number: 2008935188

For all general information contact Arcadia Publishing at:
Telephone 843-853-2070
Fax 843-853-0044
E-mail sales@arcadiapublishing.com
For customer service and orders:
Toll-Free 1-888-313-2665

Visit us on the Internet at www.arcadiapublishing.com

This book is dedicated to my husband, Bill Arick, for his professional assistance, patience, and continuing devotion to the future vision of the Lincoln Highway in Indiana; and to my parents for sharing their road memories and for taking me on long road trips across America. Lastly, this book is written to honor three generations of my father's family (Paul Shupert, Edbert Shupert, and Glen Shupert) who labored in the carriage and automobile industry in northern Indiana at the Elcar Motor Car Company and at Studebaker's. It is my hope that the reader will be inspired to take a slower journey along the Lincoln Highway and rediscover America.

CONTENTS

ACKNOWLEDGMENTS

The process of gathering information and images for this publication has taken me to archives across the state of Indiana, to Stan Hywet Hall and Gardens in Akron, and to the University of Michigan Special Collections Library that holds the official Lincoln Highway Association archive. I would like to thank the following individuals and institutions for supporting this work, which is intended to be a tribute to the Lincoln Highway heritage in Indiana. The work is also a call to preservation-minded individuals and organizations that wish to save a part of history by transforming an old gas station or tourist camp along the Lincoln Highway corridor into something new. This book is published during the bicentennial celebration of Pres. Abraham Lincoln's birth. Indiana was Lincoln's boyhood home and the legacy of the Lincoln Highway, named in his honor, continues to be an important asset to the state today.

I would like to thank Todd Zieger of Historic Landmarks Foundation, David Hay, D. Lowell and Miriam Nissley, Mark J. Heppner of Stan Hywet, John Martin Smith, Jeanette Brown, Brian Butko, Mike Kelley, Dana Groves, Kurt Garner, Cynthia Joyce, Roger Myers, Jerry Nesbitt, Patrick McIver, Chuck Mathieu, Dean and Deb Stoops of the historic Kimmell House, Joyce Crowell, Earlene Nofziger of the Goshen Historical Society, Colleen Huddleson, Martha Heinek, Rob Heinek of New Carlisle, Angie Quinn, Elkhart County Historical Society, Randy Elliott, Todd Pelfry, Russell Rein, Kathleen Dow of the University of Michigan Special Collections Library, Scott Schuler and Jennifer Johns of the Northern Indiana Center for History, Toni Cook, Andrew Beckman of the Studebaker National Museum, Fern Eddy Schultz and staff at the La Porte County Historical Museum, Kathy and Rosalie Mack at the Wanatah Historical Society, Kristin Poerschke for the Lincoln Highway Heritage Corridor in Ligonier, Pennsylvania, and Mayors Terry McDonald and Patty Fisel. Thanks also to Paul Gilger of the Lincoln Highway Association, Louis Ternet, Kim Parker of the Indiana University South Bend Education Resource Center, and the following dedicated members of the Indiana Lincoln Highway Association: Joyce Chambers, Jim Bevins, Ken Locke, Monte and Bev Gillespie, Gary and Paula Satkamp, Linda Rippy, Art Schweitzer, and my very special friends Michael and Andrew Weigler.

INTRODUCTION

The Lincoln Highway across Indiana is a story that begins long before the advent of automobiles. Early Native American pathways, most importantly the Ridge Road in eastern Indiana and the Sauk Trail in northwestern Indiana, were used for trade and migration for centuries. These paths would become incorporated into the nation's first transcontinental road.

The importance of Indiana automotive history cannot be overstated. More than 200 automobile makers are known to have existed in the state during the early decades of the automobile. The Studebaker Corporation of South Bend evolved into the only large assembly-line, mass-production facility in Indiana. Small auto shops that had used the handmade stall-built production process all fell aside in the end, but their contributions remain huge. Hoosiers grew to love their automobiles, good roads, and the joy of travel.

Traces of the early Indiana automobile industry and the vehicles produced during the early 20th century may be found in many Indiana communities including the following: the Indianapolis Motor Speedway Hall of Fame and Museum in Speedway, the Studebaker National Museum in South Bend, the Auburn Cord Duesenberg Museum and the National Automotive and Truck Museum of the United States in Auburn, the RV Hall of Fame and Museum in Elkhart, and the La Porte County Museum, the Elwood Haynes Museum, and the City of Firsts Automotive Heritage Museum in Kokomo.

Soon after the idea of the first transcontinental road was announced by Carl Fisher and the Lincoln Highway Association (LHA), communities across Indiana touched by the route began to make plans for road and bridge improvements. Local good roads clubs had already been formed by automobile owners as part of the good roads movement, but they took on new excitement at the thought of an improved coast-to-coast route.

Good roads demanded road-building materials and concrete. Indiana's geological history provided the natural resources required. Indiana businesses responded to the need by their willingness to develop new equipment and techniques for road building. The first section of concrete to be laid in Indiana was poured in Allen County on the Lincoln Highway east of Fort Wayne by the Brooks Construction Company. Rieth-Riley Construction Company was formed in Goshen and received the first contract for highway construction, paid at least in part by the State of Indiana and the federal government. Rieth-Riley is in existence today as a leader in road building and has an office on the Lincoln Highway in Goshen.

Iron-truss bridges built in the late 1800s were soon replaced by concrete spans to carry the weight of goods being transported across northern Indiana. A few iron bridges that were bypassed by later alignments have survived into the 21st century. They are precious specimens

of the evolution of roads across the state and yet another reminder of days gone by. Fort Wayne's Lincoln Highway Bridge, with a span that included five arches, was used as a model bridge by the LHA as part of its highway beautification program.

An impressive list of Indiana towns and cities touched by the Lincoln Highway alignments took on the Lincolnway name showing local enthusiasm for the route. Vice Pres. Thomas Marshall came to Indiana to dedicate the road in 1915. Sent by Pres. Woodrow Wilson, Marshall gave speeches and rode in touring cars in long parades to show his support for the progress his home state was demonstrating.

Local entrepreneurs responded to the needs of Lincoln Highway travelers and a boon in tourism by building gas stations, tourist cabins, automobile camps, cafés, hotels, as well as auto parts and tire stores and garages. During this period of transition from the use of horses to the automobile, Indiana's communities were literally transformed. Liveries and blacksmith shops became auto garages and gas pumps sprung up in amazing numbers. Fort Wayne became the gas pump capital of the world.

Preservation of this rich automobile and road heritage appears to be something that may once again transform northern Indiana as it did when the Lincoln Highway was birthed in the second decade of the 20th century. With increased interest in traveling the two-lane roads of America, Indiana has a rich heritage to draw from for heritage tourism. Towns and cities that understand this rich heritage will benefit from heritage-tourism dollars by partnering with businesses and citizens to save road-related structures and sites. Local preservation organizations and the Historic Landmarks Foundation of Indiana can become strong advocates for preservation as well as providing access to available resources and preservation tools.

Many individuals have been willing to share their stories relating to Indiana's section of the Lincoln Highway with historic sites surveyors who have been documenting structures that survive along the route. By knowing what structures survive and knowing the history behind those structures there is a greater chance of saving them for the future. Other historic roads have had some success through the work of the National Road Association and the Pennsylvania Lincoln Highway Heritage Corridor. To that end, this book is intended to be a call to preserving Indiana's Lincoln Highway.

One

VISIONARY LEADERSHIP

Few people possess the vision that Carl Fisher provided in the early days of the automobile industry. Fisher's fortitude and ability to persuade others of the need for good roads went far beyond what most people would have dreamed possible. He had no patience to wait for the local, state, or federal government to create and implement a plan for a road system for America. He believed the private sector could move the process forward and demonstrate what good roads and transcontinental travel could mean to commerce. Fisher and his sidekick, James Allison, worked together to inspire the automobile industry to create the first coast-to-coast automobile highway. Allison provided the business skills while Fisher was the visionary. The automobile industry was a beneficiary, but the most dramatic result was that a passable route across the nation was opened up for personal travel. For the first time, tourists were able to stop where they wanted, eat when they wanted, and travel to places the trains did not go. Carl Fisher's vision renewed a sense of patriotism and achievement that changed the nation.

Frank Seiberling of Goodyear Tire provided a $300,000 pledge to the Lincoln Highway Association (LHA) immediately following Carl Fisher and James Allison's invitation to dinner at the German House in Indianapolis in 1912. Fisher asked Seiberling to join the LHA board of directors in 1913. Seiberling served as president of the LHA board for two-thirds of its existence between 1913 and 1928. Goodyear printed and supplied 65,000 copies of a helpful booklet for tourists traveling the Lincoln Highway. As a board member and president, Seiberling oversaw the development and completion of the seedling mile program, the building of the Ideal Section, and the first U.S. Army transcontinental convoy along the Lincoln Highway in 1919. Seiberling sent the Goodyear band to South Bend to join the military convoy that then played all the way to San Francisco in support of the troops. Frank Seiberling financed the Goodyear Pass in the Utah desert and traveled the Lincoln Highway to assess its condition. Frank Seiberling's commitment to the Lincoln Highway was extraordinary and spanned the full term of the association's existence. From his initial pledge in 1912 to the disbanding of the LHA's office in Detroit in 1928, Seiberling was devoted to the nation's first transcontinental automobile highway.

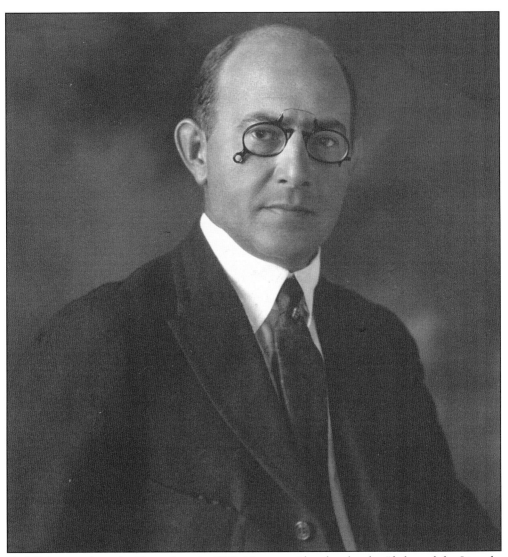

Carl Fisher was born in Greensburg in 1874. Now considered to be the "father of the Lincoln Highway," Fisher became part of the automobile craze that would change the nation forever. Fisher's reputation was one of automotive and promotional genius. He raced from bicycles to automobile lamps to being a founder of the Indianapolis Motor Speedway. He was the man behind both the Lincoln and the Dixie Highways—a national system of paved roads that ran from New York to San Francisco and from north to south via Sault Ste. Marie, Michigan, and Chicago on the Dixie Highway to Miami Beach. His roads intersected along the Lincoln in South Bend, on the 1913 original route on the Lincoln Highway in Indiana, and in Plymouth, on the later 1926 route. Fisher provided the vision that was required to create the nation's first transcontinental automobile road. (Courtesy of the LHA collection/University of Michigan.)

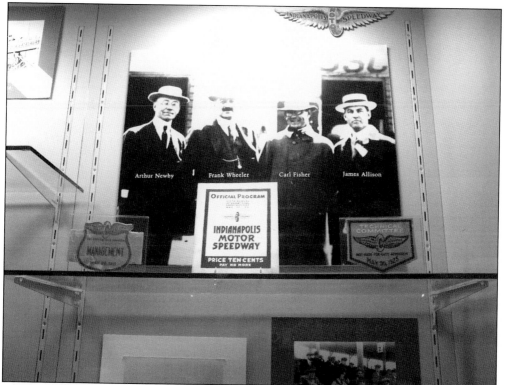

In 1912, Fisher and his friend and savvy business associate James Allison invited automobile leaders to a dinner at the Antheneaum, or German House, in Indianapolis. At the dinner, Fisher announced the idea for a coast-to-coast highway stretching from New York City to San Francisco. Fisher planned to fund the highway through private donations. Allison was the business-minded partner bringing levelheaded decision making to the project. (Author's collection.)

YOU ARE REQUESTED TO ATTEND A DINNER
GIVEN BY
CARL G. FISHER AND JAS. A. ALLISON
AT THE GERMAN HOUSE
ON TUESDAY EVENING, SEPTEMBER TENTH
NINETEEN-TWELVE

SEVEN O'CLOCK

Automotive and parts manufacturers in Indianapolis, Ohio, and Michigan received this formal invitation to attend a dinner at the German House, known today as the Rathskellar, in Indianapolis. Attendees were the invited guests of Fisher and Allison, who had been close friends and business associates since the bicycle craze. The dinner was followed with a plea to join the effort to build a transcontinental highway in time for the Panama-Pacific International Exposition in 1915. (Courtesy of the LHA collection/University of Michigan.)

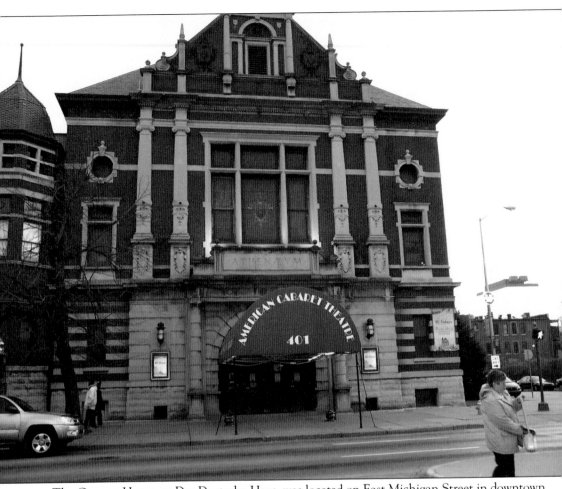

The German House, or Das Deutsche Haus, was located on East Michigan Street in downtown Indianapolis. It was originally built for the large German immigrant population. A sum of $32,000 was needed to purchase the two lots at Michigan and New Jersey Streets, where Das Deutsche Haus was to be built. The surrounding area, now known as Lockerbie Square, was a German residential area. The construction was done in two phases, first the east wing and later the west wing. By 1896, $160,000 in capital had been raised for the construction of Das Deutsche Haus. Construction of the east wing began in May 1893 and was completed in 1894. The east wing included a bowling alley, lecture hall, gymnasium, billiards room, formal dining area, ladies' parlor, men's barroom, library, *biergarten*, and meeting rooms. The motto inscribed on the east tower reads *Frisch, Frei, Stark und Treu* (vibrant and free, strong and loyal). The west wing was completed in 1898. It featured a grand theater/ballroom, a 360-seat auditorium, a large bowling alley, a bicycle storage room, and multiple clubrooms and parlors. (Author's collection.)

Henry Joy, president of the Packard Motor Car Company in Detroit, suggested to Carl Fisher that the first transcontinental highway would make a very fitting and appealing living memorial to Abraham Lincoln. In 1913, the road officially became known as the Lincoln Highway and national support became a symbol of patriotism. (Courtesy of the LHA collection/ University of Michigan.)

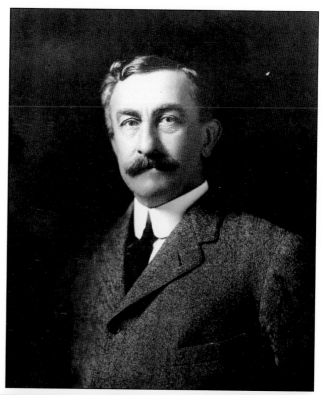

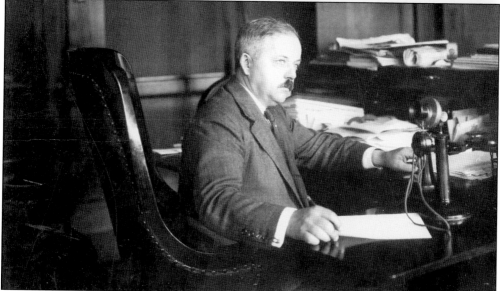

Following Fisher's plea to leaders of the automotive industry, Frank Seiberling of Goodyear Tire pledged $300,000 to the highway. Sieberling would serve as president of the LHA for two-thirds of its existence. He oversaw the seedling mile projects and the transcontinental convoy and worked to improve the highway in the West. He leveraged corporate support and donated personal funds. Seiberling was an active participant from 1912 to 1928. (Courtesy of Stan Hywet Hall and Gardens.)

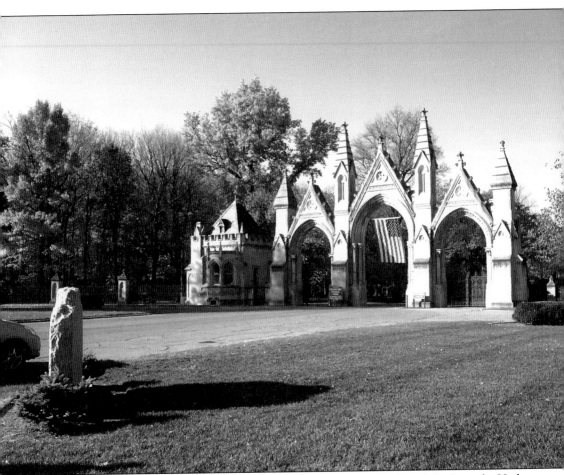

Crown Hill Cemetery is the final resting place of Carl Fisher, father of the Lincoln Highway. Located at 700 West Thirty-eighth Street in Indianapolis, the cemetery is the third-largest nongovernment cemetery in the country. Crown Hill Cemetery was dedicated on June 1, 1864. It is interesting to note that Fisher was buried on his Dixie Highway, which originally served as the main entrance. The cemetery's most beautiful structures are the waiting station and the Gothic chapel, both of which were built in the late 1800s. With over 555 acres and 25 miles of paved road, Crown Hill is the final resting place to over 185,000 citizens. One of the most historically significant sites in Indiana, Crown Hill is the burial site of such famous people as Pres. Benjamin Harrison, Col. Eli Lilly, 11 Indiana governors, one Kentucky governor, 14 Indiana mayors, 13 Civil War generals, poet James Whitcomb Riley, author Booth Tarkington, automobile manufacturer Frederick Duesenberg, and the infamous bank robber John Dillinger. (Author's collection.)

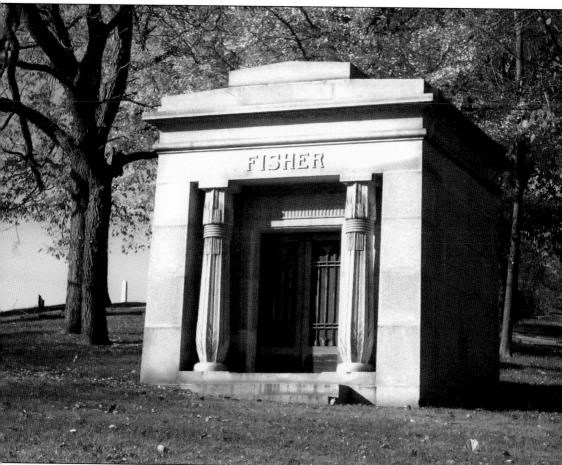

Carl Fisher's remains are laid to rest in the Fisher family mausoleum located in Crown Hill Cemetery in section 13 of lot 42. Fisher was born on January 12, 1874, in Greensburg and died in Miami Beach on July 15, 1939. He was cremated and his urn brought to the Fisher mausoleum in 1943. Not only is he considered the father of the Lincoln Highway, he was also the founder of the Dixie Highway. He developed Miami Beach and lost his fortune during the great crash in 1929. The Fisher mausoleum stands prominently on a hillside and is built in the arts and crafts style with Egyptian-style copper patina motifs symbolizing durability, devotion, and honor. The materials used to build the sophisticated structure include Indiana limestone and a detailed wrought-iron entrance. The Fisher surname is engraved above the door. (Author's collection.)

James Ashbury Allison was born in Marcellus, Michigan, on August 11, 1872, and died in 1928. Allison was an American entrepreneur and businessman. He invented the Allison Perfection Fountain Pen and with Carl Fisher was a founder of Prest-O-Lite, a manufacturer of automobile headlights. With Fisher, Frank H. Wheeler, and Arthur C. Newby, he was a founder of the Indianapolis Motor Speedway and the Indianapolis 500-mile race. Allison formed the Indianapolis Speedway Team Company, later known as the Allison Experimental Company and later as the Allison Engineering Company, which was eventually purchased by General Motors, becoming the Allison Division of General Motors. Allison died of pneumonia in 1928 at the age of 56 and was buried in Crown Hill Cemetery in Indianapolis near the Fisher family mausoleum. His Indianapolis estate was known as Riverdale, with landscapes designed by Jens Jensen. It is now part of Marian College. (Author's collection.)

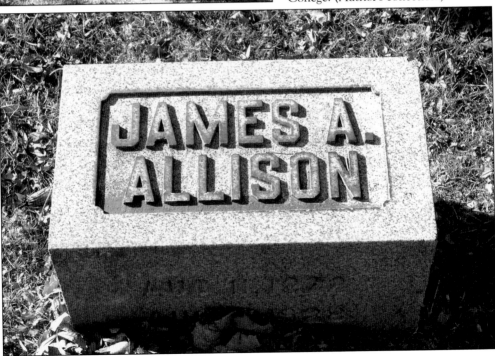

Two

A SUMMIT CITY WELCOME

The first roads in northeastern Indiana were Native American trails or narrow paths traversed in some places only in single file. Many trails crossed northern Indiana before the land was surveyed and sold to settlers in the first half of the 19th century. Settlers were sometimes forced to "blaze" or cut roads to reach their land. These roads were seldom straight and road conditions were poor. One of the first roads in northeast Indiana was the Fort Wayne to Goshen Road, which became the Lincoln Highway in 1913 and then U.S. 33 in 1926.

Fort Wayne is the largest city along the Lincoln Highway between Pittsburgh and Chicago and has long been a center for trade. In the canal days, the Wabash and Erie passed through Fort Wayne's center bringing settlers and goods. With the advent of the railroads, Fort Wayne became the home for the Pennsylvania Railroad shops that included rail yards, locomotive repair shops, and a roundhouse. As the automobile age emerged, the S. F. Bowser and Company's ingenuity and foresight made Fort Wayne the gas pump capital of the world.

The original Lincoln Highway route through eastern Indiana touched rural agricultural areas, the small communities of Zulu and Townley, the 19th-century French settlement known as Besancon, the canal town of New Haven, and the city of Fort Wayne. The route then headed northwest to Churubusco and into lake country where urbanites have traditionally fled in great numbers during the hot and humid summer months.

The Lincoln Highway was celebrated through northeast Indiana. A good road meant profits for farmers who needed to get goods to market, improved commerce, and more tourists. The city of Fort Wayne celebrated the Lincoln Highway with long parades and bonfires. The city built arches to welcome travelers and the Daughters of the American Revolution (DAR) erected a huge flagpole at the city limits to show their patriotic efforts. The eastern portal city of the Lincoln Highway had much to gain from Carl Fisher's dream.

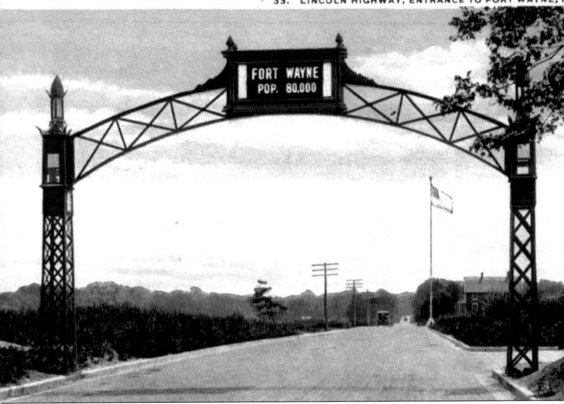

In 1914, the LHA reported that an arch was being built over the road at Fort Wayne. "Indiana is a red letter state for Lincoln Highway enthusiasm and activity. Bond issues over $275,000 were raised this year for improvement of 'the Way' between her borders and hundreds of miles of road have been marked with the official marker of the Association. There is nothing slow in Indiana. These Hoosiers get things done." A number of towns along the Lincoln Highway erected entrance arches to welcome travelers to their Lincoln Highway town. Fort Wayne built two—one at each city limit along the corridor. This postcard shows the arch that stood at the Fort Wayne eastern city limit on Maumee Avenue. The arch boasted a population of 80,000. Lights at each end of the arch marked the entrance for nighttime travelers. The flagpole along Maumee was donated by the Mary Penrose Chapter of the DAR in 1915. (Author's collection.)

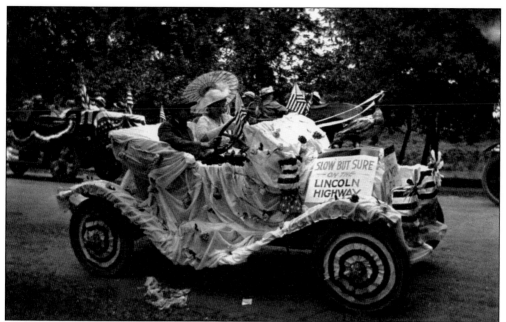

On June 21, 1915, one of the most successful and significant public demonstrations ever held in Fort Wayne marked the dedication of the Lincoln Highway. An automobile parade miles in length passed through the city and went to New Haven and back. This car was decorated by the Kruper family. James B. Crankshaw's automobile was awarded first honors for artistic beauty. Local businesses ran sales on automobile clothing and Brownie cameras. (Courtesy of the Allen County Historical Society.)

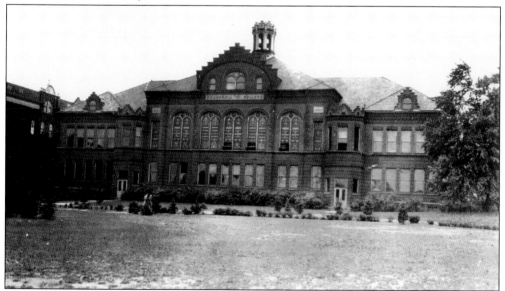

Fort Wayne pulled out all the stops when it came time to dedicate the Lincoln Highway on June 21, 1915. From the DAR's flagpole dedication to an automobile parade stretching miles in length, the city celebrated its position on the nation's first coast-to-coast automobile highway. Vice Pres. Thomas Marshall came to participate. A crowd of several thousand gathered at Concordia College for speech making and entertainment. (Courtesy of the Allen County Historical Society.)

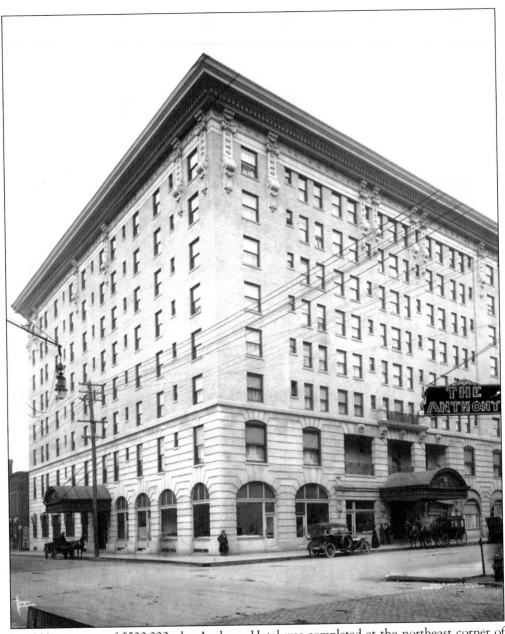

In 1908, at a cost of $500,000, the Anthony Hotel was completed at the northeast corner of Berry and Harrison Streets on the Lincoln Highway in downtown Fort Wayne. The Anthony was the community's meeting place and was advertised to tourists as a fireproof hotel. It stood nine stories high, featured 263 guest rooms, a fine dining room, and an elaborate lobby. H. J. Keenan was the manager for many years. In 1924, eight hotels served travelers in Fort Wayne, but the Anthony was the grandest venue and served as a control point for the Lincoln Highway. Visitors could stay the night or stop to inquire about travel conditions to the east or west along the route. For travelers desiring to keep accurate mileage records, the "controls" were points where speedometer readings were taken and reset to zero. In 1974, it took just 294 explosive charges and nine seconds to bring it down. (Courtesy of the Allen County Historical Society.)

In the early years of transcontinental travel there were few maps to assist drivers, but by comparing odometer readings to the information on distances between towns listed in the official Lincoln Highway guide, travelers could estimate their location and their travel distances between points. Signs also assisted travelers. The LHA provided official red, white, and blue Lincoln Highway Control Point signs to these locations. Signs were placed on buildings in each community that had a control point. Some points were elaborate hotels, but in more remote areas, local landmarks were often used. When drivers reached these points they would reset their odometer to zero before departing to the next town or control point. (Courtesy of the Allen County–Fort Wayne Historical Society.)

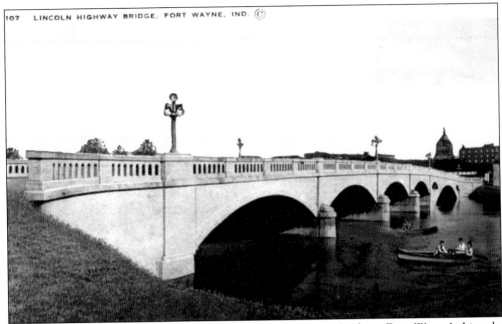

LHA promotional efforts included the building of concrete bridges. Fort Wayne's Lincoln Highway Bridge opened in April 1916 over the St. Mary's River at a cost of $200,000 as part of Harrison Street. A photograph of the bridge was printed in the Lincoln Highway guide as an example of how bridges could be designed to beautify communities and enhance the traveler's experience. This attitude was part of a progressive philosophy adopted by the State of Indiana in the matter of road improvement. By 1916, state pride was linked to fine roads and artistic bridges. The bridge survives albeit severely altered due to the removal of the spans. The granite plaque shows that it is 724 miles to New York and 2,660 miles to San Francisco. Today the bridge is part of a greenway bike and pedestrian system. (Author's collection.)

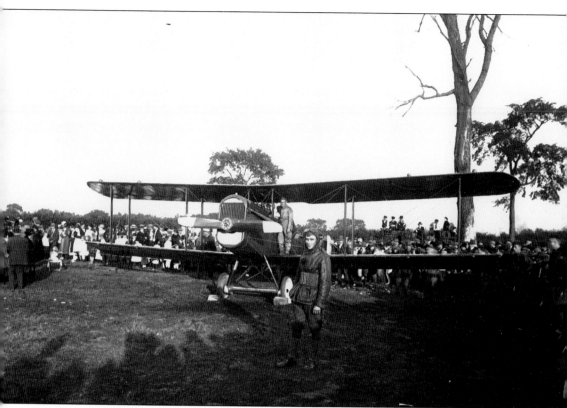

After the end of World War I, Fort Wayne created a park along the Lincoln Highway to honor veterans of World War I. The park was designed as an automobile park with a drive that provided access to an elliptical path along plantings of memorials trees with tags that identified soldiers lost in the war. Memorial statues, a pavilion, picnic areas, a lit cavelike grotto, and a baseball diamond were included. Aviator Art Smith, known as Fort Wayne's daredevil "Bird Boy" aviator tested his early airplanes along the Lincoln Highway on land that would become Memorial Park. Financed by his parents through a home mortgage, Art and his wife, Aimee, attracted large crowds interested in early airplanes. Art traveled around the world flying planes and holding skywriting events that made headlines in major newspapers. Following his death, a large obelisk was erected to honor his contribution to the world of aviation. (Courtesy of the Allen County–Fort Wayne Historical Society.)

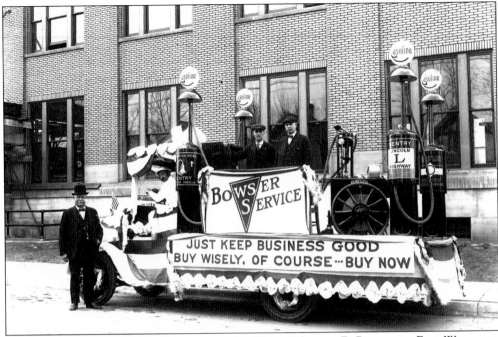

The first gasoline pump was invented and sold by Sylvanus F. Bowser in Fort Wayne on September 5, 1885. This pump was used for kerosene lamps and stoves. The term *bowser* was used to refer to a vertical gasoline pump. Although the term is not used anymore in the United States, it still is used sometimes in Australia, New Zealand, and Canada. The Bowser Company produced special gas pumps for filling stations along the Lincoln and Dixie Highways. The company had an agreement with the LHA that Lincoln Highway pumps would be available only to businesses along the official Lincoln Highway route. This photograph captures the Bowser Company's 1915 Lincoln Highway Day parade entry featuring the Sentry Pumps for the Lincoln and the Bowser Oil Pumps. Sylvanus F. Bowser is on the left. (Courtesy of the Allen County–Fort Wayne Historical Society.)

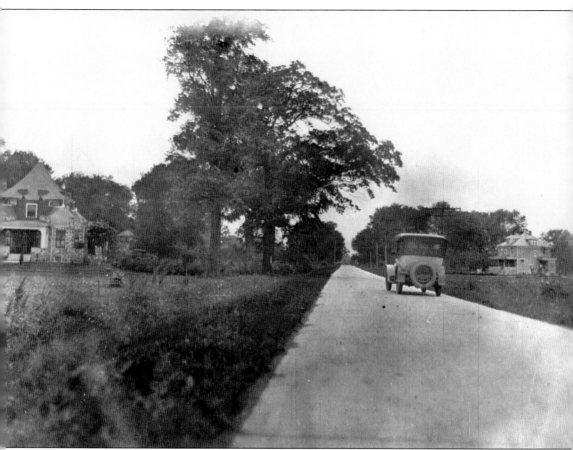

There must have been a shout of excitement from the youngsters as they saw the big car coming down the road. The traveling white Packard, whose passengers were Lincoln Highway officials, must have created great excitement along the road. The official car was often a main entry in parades. The LHA's field secretary drove the official car as he made trips along the corridor to inspect road conditions and make contact with local officials about the status of road improvements. Taken in 1917, this photograph captures the Packard as it passes houses east of Fort Wayne, near New Haven. Notice the state-of-the-art section of concrete, measuring 14 feet wide, that must have beckoned locals to go out for a drive. The castlelike house on the left is known as Holter's Roost. This section of the road is called Old Maumee Avenue and runs parallel to U.S. 930, which is now Lincolnway West in New Haven. (Courtesy of the LHA collection/University of Michigan.)

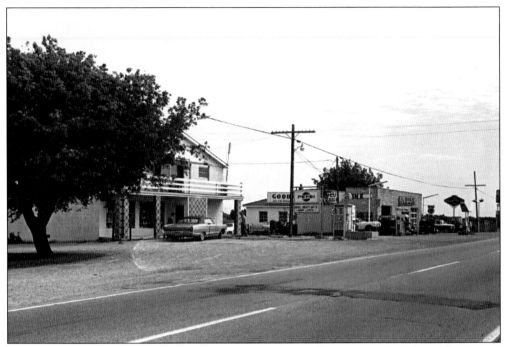

Zulu is an unincorporated town in Jefferson Township, Allen County. It is located just west of the Ohio line. In earlier decades, Lincoln Highway travelers would have driven past tourist cabins, cafés, small gas stations, and an interurban line. They might have been tempted to stop at Oberley's Lunch for a sandwich or purchase gas at the Standard Oil station. This photograph was taken in 1941. Billy's Tavern is in business near Zulu today, but the other businesses are closed. The village of Zulu was named by locals who threw a dart at a world map. The dart landed on Zulu, Africa. (Courtesy of the Ternet collection.)

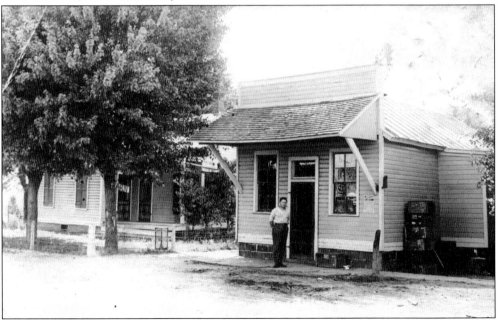

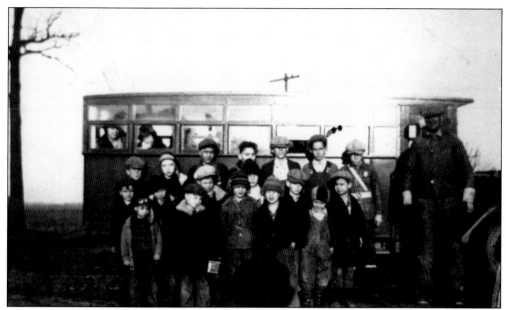

Today Allen County is filled with abandoned one-room schoolhouses, but this photograph captures students from Jefferson Township preparing to enjoy a ride on the school's hack along the Lincoln Highway east of New Haven. The children in this area were descendants of French settlers who came to Allen County in the 1850s from Besancon, France. The area attracted French immigrants who set up large farms and small businesses to create a successful community that continues into the 21st century. The schoolhouse was located on the original route, but children were put in danger as they had to cross the road to get water at a farmhouse across the road. A number of years later, an alignment was built on the south side of the school along the interurban line. After school consolidations, the old school became a speakeasy. (Above, courtesy of the Besancon Historical Society; below, courtesy of Joyce Chambers.)

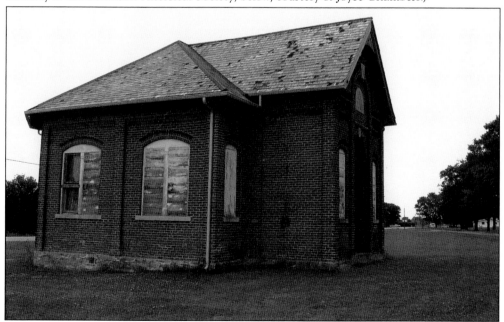

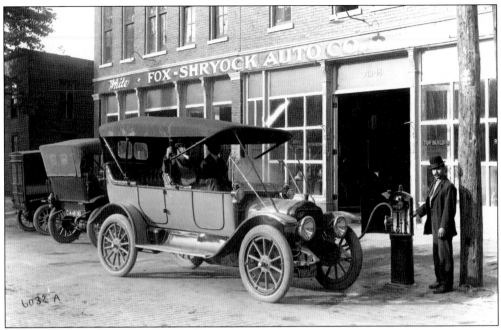

Soon after Lincoln Highway officials proclaimed the actual route, automobile garages were opened in nearly every small and large town along the route to serve travelers. Breakdowns and flat tires were frequent. This photograph captures a scene at the Fox garage and automobile dealership believed to be on Harrison Street in Fort Wayne. (Courtesy of the Allen County–Fort Wayne Historical Society.)

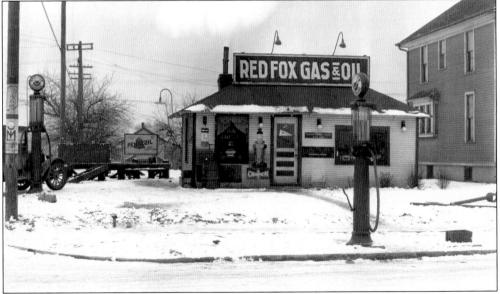

The Red Fox Gas and Oil station was located at State and Wells Streets at the western city limits. This was a turning point for the Lincoln Highway and the location of the west entrance arch that welcomed travelers. A curved porcelain sign on the filling station indicates the turning point. The Hoosier State Auto Association painted poles marking the route as State Road 2. Candy bars sold for 5¢. (Courtesy of the Allen County–Fort Wayne Historical Society.)

Three

TRAVELING THE FORT WAYNE TO GOSHEN ROAD

Many Native American trails crossed northern Indiana before the land was surveyed and sold to settlers. Often forced to blaze or cut and clear roads themselves, the pioneers in northern Indiana created paths to reach their newly purchased land. These roads were seldom straight and during most of the year the road conditions were poor, but the trails had laid the path for improved roads and modern highways.

One of the first roads in northeast Indiana was the Fort Wayne to Goshen Road, which later became the Lincoln Highway and then U.S. 33. This section of the Lincoln leaves the city of Fort Wayne and heads in a northwesterly direction to the city of Goshen. This is the most romantic section of the Lincoln Highway across Indiana. The road winds past farm fields, historic farmsteads, and all types of barns. The gentle hills and curves cut across meandering streams into a wide region filled with lake resorts. Quaint towns found along the route include Churubusco, Wolf Lake, Merriam, Kimmell, Ligonier, Benton, and Goshen.

Kumback Sauce or Comeback Sauce is sauce that is supposedly so good one will come back for more. The sauce was a combination of Thousand Island dressing, remoulade, ketchup, mayonnaise, Worcestershire sauce, mustard, and pepper. This Fort Wayne food stand was located on the western edge of town and offered the specially prepared meat to Lincoln Highway travelers. (Courtesy of Russell Rein.)

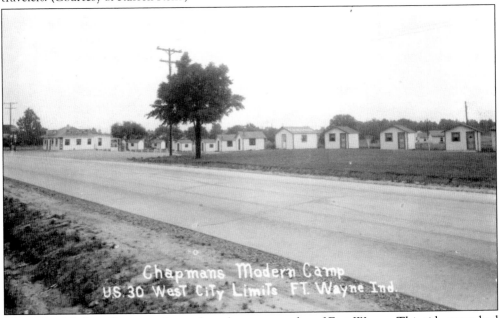

Chapmans Modern Camp was located on the western edge of Fort Wayne. This tidy camp had over a dozen cabins precisely decorated with lace curtains, rose trellises, and screen doors. At the main building, guests could purchase lunch or fill up their gas tanks at the twin pumps. This camp may have been named in honor of local folk hero Johnny Appleseed, whose real name was John Chapman. (Courtesy of Russell Rein.)

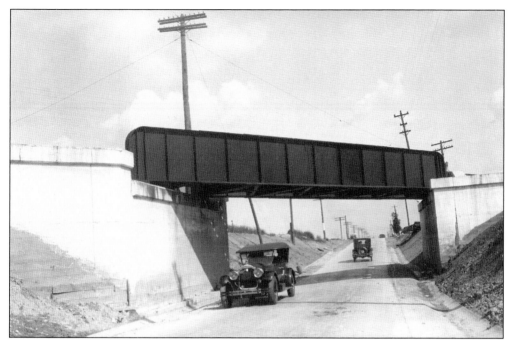

The LHA promoted road safety through the separation of railroad tracks from the automobile road. This separation or underpass was newly completed when the photograph was taken by the field secretary. The underpass is located on Goshen Road, two miles west of the 1924 city limits, which would have been near State Street and Goshen Road. (Courtesy of the LHA collection/University of Michigan.)

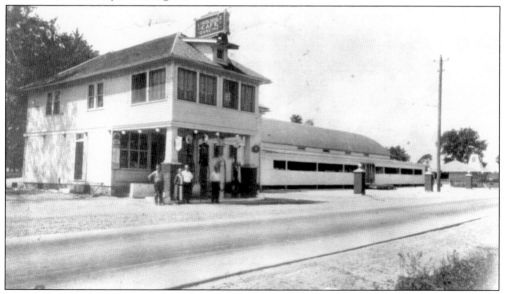

Lincolndale Café was located on the western edge of Fort Wayne along Goshen Road. The original route of the highway continued on north to Churubusco from this point. The 1926 route turned west on Washington Center Road. The Lincolndale area of the highway was completely altered when Interstate 69 was built through the area. Road construction caused sections of the original route to become dead ends. (Courtesy of Russell Rein.)

The Black and White Motel was located on Goshen Road and was named for its color scheme. This was a one-stop—a business offering gasoline, tourist cabins, and meals to travelers. Personal accounts from the son of the former manager include stories of gypsies stopping to repair tires and engines. They were helped by the manager and then the party would move on to the next town. (Courtesy of Russell Rein.)

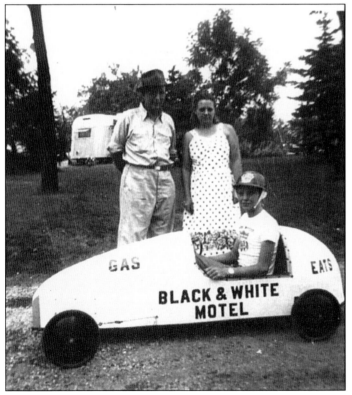

The managers of the Black and White Motel had a clever way to advertise their Fort Wayne business. They entered their son and his homemade go-kart in local races. The manager's family lived in the stainless steel trailer at the back of the camp, which was located on Goshen Road—the Lincoln Highway. (Author's collection.)

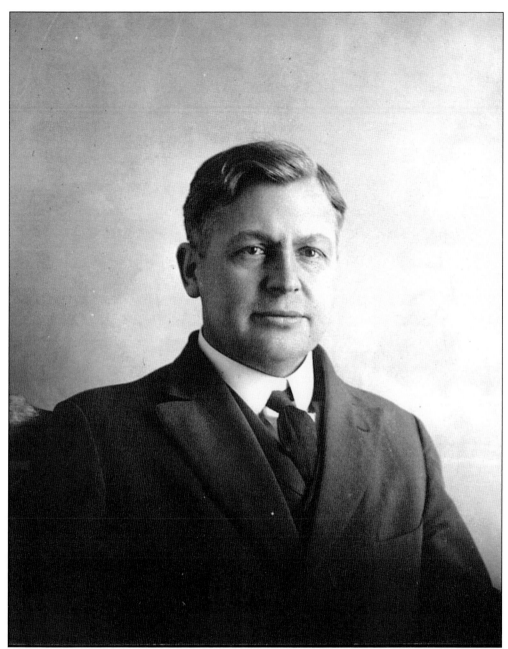

For many years, the Lincoln Highway consul or highway point person in Churubusco was F. B. "Doc" Weaver. Doc was a local leader and served the Churubusco community as a dentist and as the secretary of the Churubusco School Board. His office was located in the iron-shaped building in the center of town known as the Central Building. After the LHA closed its offices in Detroit, the association presented local consuls with a book published by the LHA in 1935 for their volunteer service. During the time of Doc Weaver's service to the road, the population of Churubusco was 1,000. The mileage to New York was 722 miles. San Francisco was 2,609 miles to the west. It was only 14 miles to Fort Wayne and 3 miles to Merriam. (Courtesy of the LHA collection/University of Michigan.)

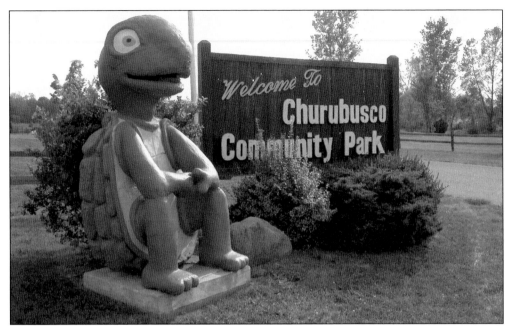

In 1949, rumors spread across northeastern Indiana that a gigantic turtle had been sighted in a small lake near Churubusco. Gale and Helen Harris owned the lake and set about to find the mammoth turtle. The Harrises lowered the lake and hired a diver from northwest Indiana to explore the lake bottom. The turtle hunt made local, regional, and national news. The turtle hunt put Churubusco on the map. (Author's collection.)

In 1949, the town of Churubusco gained a national reputation when a turtle was sighted in one of the nearby lakes. The landowner was determined to trap the huge turtle. The hunt made the news across the Midwest. The turtle was supposedly sighted by a number of people and was said to have a shell the size of a tabletop. The lake water was lowered and divers sent to find the beast, but Oscar was never found. (Courtesy of Chuck Mathieu.)

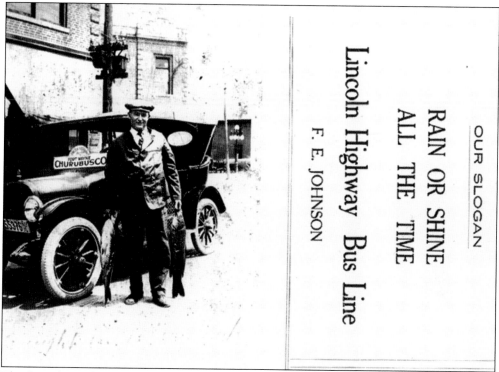

OUR SLOGAN

RAIN OR SHINE
ALL THE TIME

Lincoln Highway Bus Line

F. E. JOHNSON

The Lincoln Highway bus line from Fort Wayne to Churubusco provided transportation to those wishing to enjoy local lake resorts. Driver F. E. Johnson poses with his impressive catch. Churubusco provided summer getaway locations for the citizens of Fort Wayne. Nearby Blue Lake advertised cottages, fishing, and a very popular dance hall. (Courtesy of Chuck Mathieu.)

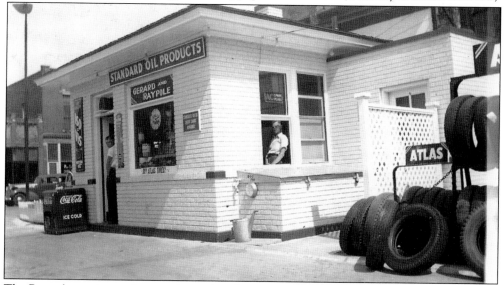

The Raypole service station was located in downtown Churubusco in the 1950s. This was the era of gas station attendants in uniforms who pumped gas and checked oil levels. Raypole's is an example of tidy automobile businesses that offered clean restrooms and good service in hopes of attracting female customers. (Courtesy of Chuck Mathieu.)

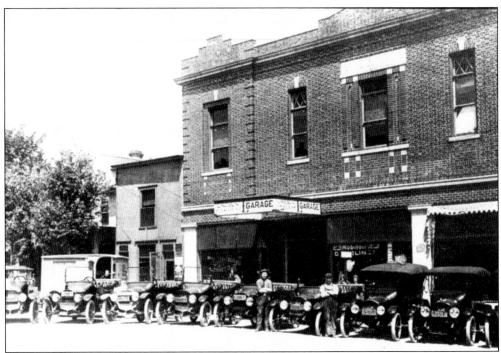

In the 1920s, the Lincoln Highway garage in Churubusco was a state-of-the-art facility. Built of brick and including interior parking for guests staying overnight at the hotel, the garage also served as the control station. There was one railroad crossing at grade, two banks, and a newspaper. (Courtesy of Chuck Mathieu.)

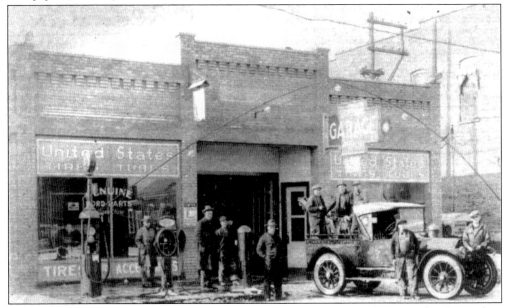

This early image of the first Lincoln Highway garage in Churubusco shows the locals standing proudly by as the excitement of the newly opened highway seems to inspire thoughts of coast-to-coast travels and tales. The garage offered a towing service and gas. A control station sign is displayed on the side of the building. (Courtesy of Chuck Mathieu.)

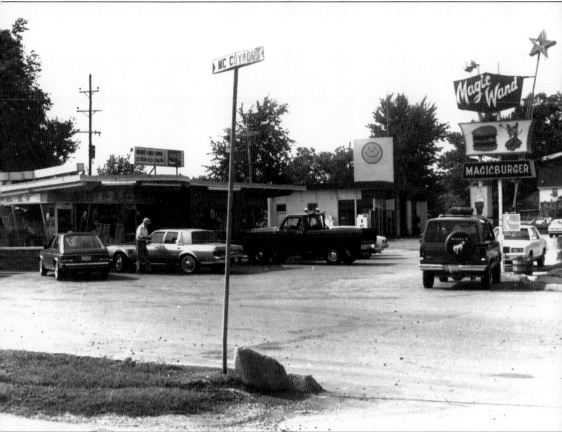

The Magic Wand Diner and Egolf's IGA sit opposite each other on the southern edge of Churubusco along the old Lincoln Highway, known today as U.S. 33. For decades, customers have been stopping to shop at the grocery or stop in the restaurant for sandwiches, sodas, and pie. For a time, there was carhop service but that has been discontinued. The Magic Wand provides great personal service and an interesting atmosphere, filled with local news and friendly chatter. Stop in for a Magic Wand hamburger. The Magic Wand is owned today by Max Myers, who has operated the diner for 42 years. A diverse collection of clowns surrounds the interior and entertains the youngsters. The hamburgers have not changed, and the apple pie and ice cream are delicious. The neon star outside continues to flash at travelers passing by to lure them inside. (Courtesy of the Whitley County Historical Society.)

Merriam is an unincorporated community at the intersection of Indiana 9 and U.S. 33 in Noble County. There are faint traces of former businesses relating to the road—an old gas station on a corner and an automobile garage tucked away from the main road on the original Lincoln Highway alignment that runs through the cemetery. (Author's collection.)

The control station in Merriam was at the local post office according to the 1924 Lincoln Highway road guide. The population was 80, and there were no tourist accommodations. The photograph of the garage above was taken by a historic sites surveyor, who is documenting automobile-related structures along the route today. (Author's collection.)

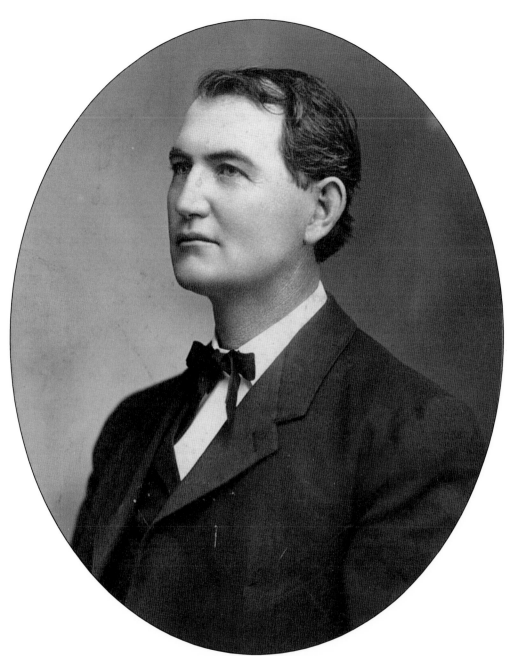

Dr. James E. Luckey served as a local Lincoln Highway consul for the LHA and was a local leader in promoting good roads. Wolf Lake had a population of 500 people in 1924 but served the summer resorts and tourists who came to enjoy the lakes of this region. Luckey loved to fish, hunt, and travel in his automobile. Professionally he and his two sons served the Wolf Lake region as physicians. A small hospital at Wolf Lake was later named after Dr. James E. Luckey. The museum displays include a large assemblage of medical supplies, clothing, books, and equipment from a bygone era. The displays are set up in an accurately re-created operating room, examination room, and doctor's office. The museum is located at the corner of U.S. 33 (the Lincoln Highway) and State Road 109 in Wolf Lake. (Courtesy of the LHA collection/University of Michigan.)

This photograph was taken in 1926 and captures a new section of concrete on the Lincoln Highway with some nice cuts and fills between Churubusco and Wolf Lake. Significant progress was made along this original 1913 stretch due to many good road supporters led by Dr. James E. Luckey of Wolf Lake, who fought to keep the highway running through this area. Luckey was the local Lincoln Highway consul. This photograph shows how much progress had been made along the original route of the Lincoln Highway across Indiana. Platted in 1832, Wolf Lake is the

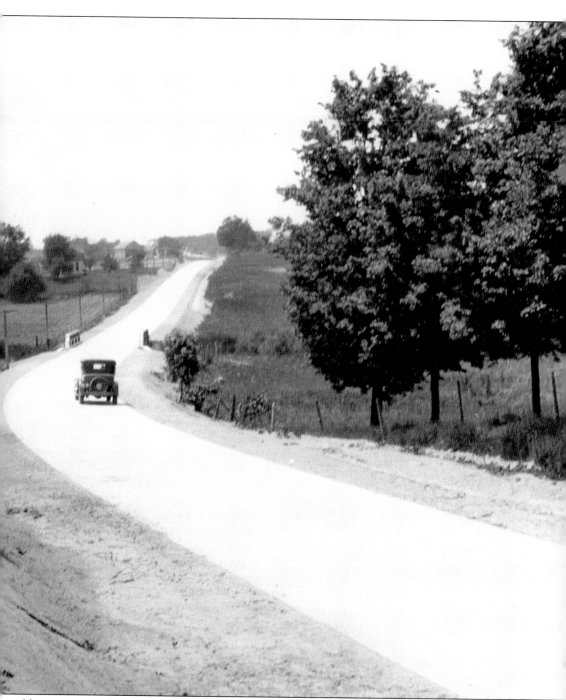

oldest town in Noble County and is located at the intersection of U.S. 33 and State Road 109 in southwestern Noble County. Today Wolf Lake is home to less than 300 residents, who celebrate their community heritage each August with the Onion Days Festival. Wolf Lake is also home to the beautiful Merry Lea Environmental Learning Center of Goshen College. (Courtesy of the LHA collection/University of Michigan.)

In the 1920s, the Wolf Lake Garage was one of eight general businesses in town. There was a hotel and one automobile garage. The control point was at the post office. The automobile garage is in business today and the building's ghost sign remains faintly visible above the garage door. The town's numbers increase during the summer months due to the area's many small lakes and outdoor recreational resources including Chain-O-Lakes State Park, directly east of Wolf Lake. (Author's collection.)

JR's Drive-In is located on the north edge of Wolf Lake and is open seasonally to serve the summer vacationers. Drive up for a Coke and a hamburger. The neon sign at the edge of the highway beckons customers to stop in. This 1950s-era diner stands in sharp contrast to aged agricultural warehouses across the street. (Author's collection.)

Built in 1876, the Kimmell House is a stately brick Italianate that beckons travelers as a romantic getaway or a retreat. Mature trees, a porch swing, and the gorgeous gardens and grounds will take the visitor back in time to the days when traffic was slower along the Lincoln Highway near Kimmell. Restored to its full glory, the Kimmell House is now a bed-and-breakfast and operates with Hoosier hospitality, providing travelers an overnight stay to be remembered. (Courtesy of Dean Stoops).

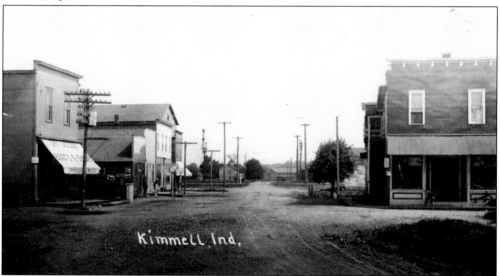

Gaerte Grain is the hub of rural Kimmell, with huge silos standing as monuments to this tiny town's rural and agricultural past and present. Once one of the largest distribution points in the nation for onions, old warehouses still line the tracks. Noble County's soil made both onion and mint crops some of the country's best. Popcorn was also stored and shipped from Kimmell warehouses, but today's commodities are corn and soybeans. (Courtesy of Russell Rein.)

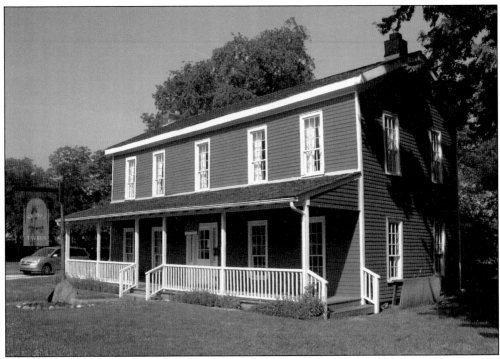

The Stone's Trace Tavern was built in 1839 by Richard Stone on the Fort Wayne to Goshen Road. This tavern site is the oldest existing building in Noble County. The tavern served as a welcome site to stagecoach passengers traveling in the 19th century. The building was used as a post office, jury room, jail, and dance hall. It is now owned by the Stone's Trace Historical Society, which hosts an annual living history fall festival on the grounds. An abandoned Lincoln Highway alignment that was part of what was once depicted in postcards and known as Stone's Hill remains between the tavern and current-day U.S. 33. (Author's collection.)

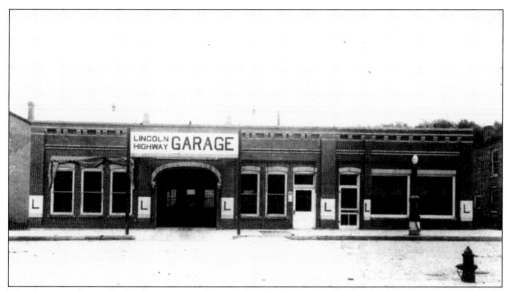

The Ligonier Lincoln Highway consuls were W. H. Wigton, who built the Zimmerman Block, and Walter Robinson, who owned the Lincoln Highway Garage at the turning point of the Lincoln Highway at Cavin and Lincolnway. The Lincoln Highway Garage was marked with huge logos and served as the control station. Gas was available at the curb and tune-ups were found inside. The garage crew paid special attention to tourists' needs. (Courtesy of the Ligonier Historical Society.)

The Indiana Historic Radio Museum and Visitor's Center is located at 800 Lincolnway South in Ligonier. The museum boasts more than 400 classic antique radios including crystal radio sets, ham radios, early transistor radios, and collectible radios of the past. The well-preserved brick building originally housed a canopy-style filling station in the 1920s. (Courtesy of Joyce Chambers.)

Historic Solomon Mier Manor stands proudly at 508 South Cavin Street in Ligonier on the Lincoln Highway and is a proud reminder of Ligonier's Jewish population. Immigrant Solomon Mier built the lavish home from profits he earned by operating banks in the region. The banks helped finance northern Indiana electric railways and connect towns to one another. (Author's collection.)

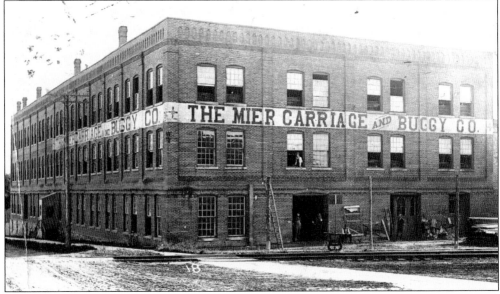

The Solomon Mier Carriage and Buggy Company built carriages. In 1908–1909, the company produced the Runabout automobile with 14 horsepower and a battery ignition. It sold for $600. The company was located at Cavin Street and Lincolnway West on the north edge of downtown Ligonier. Most of the building was disassembled and sold for reuse in 2008. (Courtesy of Mayor Patty Fisel.)

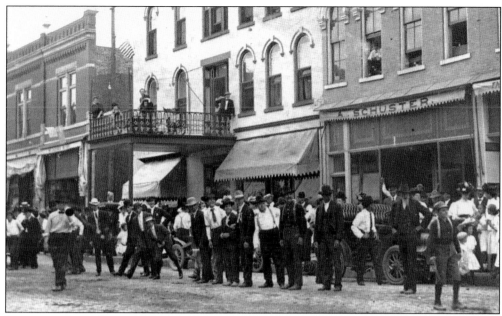

Ligonier is located in a beautiful rural area of northern Indiana where it is said that all the roads are two-lane and not all of them are paved. The sister city of Ligonier, Indiana, Ligonier, Pennsylvania, is located approximately 400 miles to the east. The founder of Ligonier, Indiana, was Isaac Cavin. Cavin founded the town along the banks of the Elkhart River in 1835. Cavin was from Ligonier, Pennsylvania, and named the new settlement after his hometown. The photograph above shows residents of Ligonier, Indiana, during an early automobile race. The view below of Ligonier, Pennsylvania, was taken from the west side of town facing east. Follow the telephone poles from the bottom right corner diagonally left and then through town to trace the path of the Lincoln Highway. (Above, courtesy of Patty Fisel; below, courtesy of Kristin Poerschke, Lincoln Highway Heritage Corridor.)

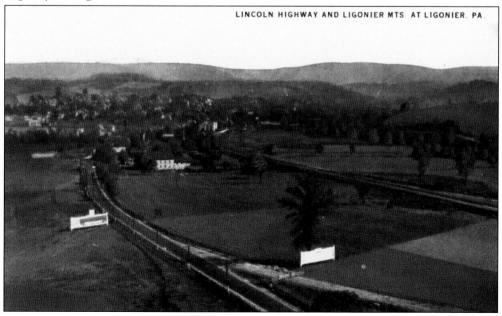

LINCOLN HIGHWAY AND LIGONIER MTS AT LIGONIER. PA.

47

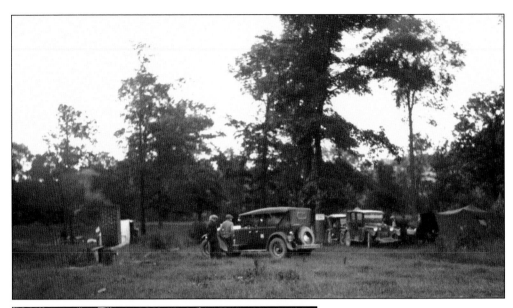

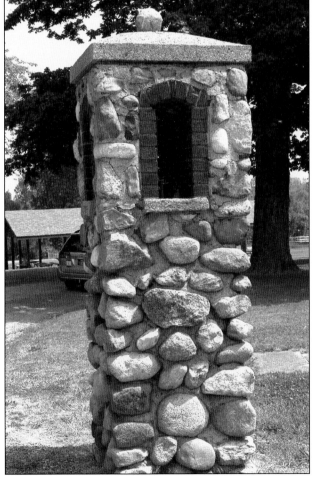

Ligonier provided a tourist camp for automobile travelers. Automobile camping became America's favorite pastime in the 1920s, and automobile camping businesses sprang up in many Hoosier communities. Awning companies began to offer a line of automobile tents. This was the beginning of what would eventually make northern Indiana the recreation vehicle capital of the world. In 1936 and 1937, the tourist camp at the west city limit became a Works Progress Administration (WPA) project as part of Theodore Roosevelt's New Deal. Fieldstone features were added to the park and included a large circular fountain, a shelter with a large stone fireplace, pedestals, and walkways. The fieldstone and limestone entrance pillars stand at the drive along Lincolnway West. Their lights have not burned for quite some time, but the park holds a rich Lincoln Highway heritage. (Above, courtesy of the LHA collection/ University of Michigan; left, author's collection.)

Four

ELKHART COUNTY CHARM

The evolution of transportation is a key component to the development of any area. In Elkhart County, the link to Native American trails and waterways is obvious as crude roads built by early settlers followed these paths. The impact of the railroad was huge as it provided outlets for farmers to larger markets in Indianapolis and Chicago. Urban railroads dotted the landscape by the beginning of the 20th century and connected a vast network of towns across the entire region. Wooden bridges were replaced with iron trusses to carry the load. Then the automobile came onto the scene and changed the world.

In 1913, a local newspaper reported that

> From the Atlantic to the Pacific coast the Lincoln Highway blazed Friday night. The name of the man who came from the people to the highest office of the people and who believed in a government of, by, for the people was written in letters of fire. Motto Noble had charge of the celebration in Goshen, and placed torches of colored fire. He says that many of them were grabbed by small boys, who carried them about. However the purpose was accomplished. Today every man and woman in Goshen is an enthusiast in favor of the Lincoln Highway. Elkhart marked its portion of the road, and Benton built a large bonfire. Anyone wishing to join the association may do so at the Elkhart County Trust company or by applying to anyone of the officers named in the article above.

It is not surprising to learn that Elkhart County enthusiastically joined the Lincoln Highway bandwagon. There was great interest in roads and automobiles across Indiana. By 1913, the state was producing the second-largest number of automobiles in the country; only Michigan was ahead of the Hoosier state. Most Indiana companies focused on the craftsman method, where cars were built one piece at a time. They made cars that were of a very high quality but that tended to be more expensive than the mass-produced vehicles.

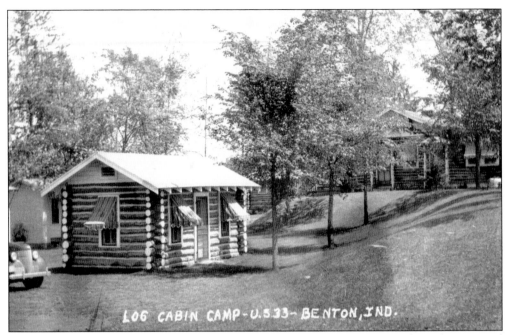

Benton is located just south of Goshen and is a sleepy town, but in 1920, the Baltimore and Ohio Railroad had a depot there and a Western Union telegraph office. The Lincoln Highway ran through town. On the south side of the river, a set of tourist cabins was built in the log cabin style. (Courtesy of Russell Rein.)

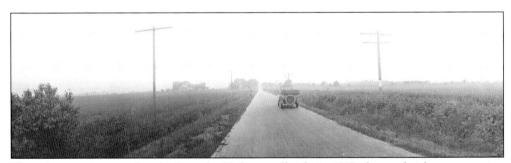

This photograph was taken by Lincoln Highway officials in 1917 along a brick paver section of the Lincoln Highway between Benton and Goshen. The Lincoln Highway was marked by painted poles along the highway. The official logo L was painted on a red, white, and blue striped background. This section of the route passed through rolling agricultural areas. (Courtesy of the LHA collection/University of Michigan.)

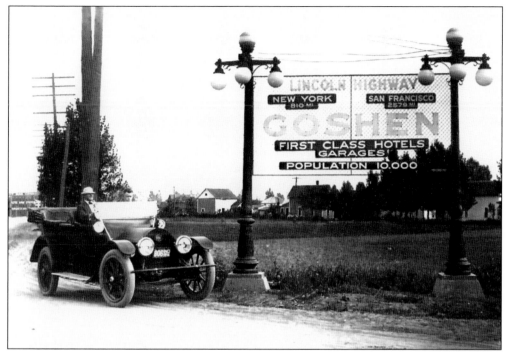

In 1915, Goshen erected entrance signs boasting a population of 10,000, first-class hotels, and automobile garages. The sign listed the mileage to New York and San Francisco. Lit globes were striped red, white, and blue and welcomed nighttime drivers. Manufactured by the Cutter Light Company in South Bend, fragments of one sign were found when the Martin's grocery store was built on Chicago Avenue in 2006. (Courtesy of Russell Rein.)

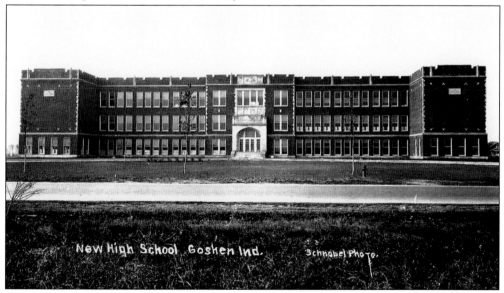

Goshen High School was built in 1923 at a cost of $400,000 on the Lincoln Highway east of Tenth Street. The building was dedicated with two ceremonies on October 5. The featured afternoon speaker was Notre Dame football coach Knute Rockne, who spoke on the importance of high school athletics. (Courtesy of the Goshen Historical Society.)

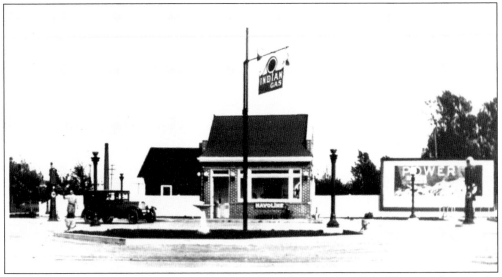

"Fill 'er up" was the phrase heard across the Lincoln Highway in the 1920s. This traveler stops for gas at 500 Lincolnway East in Goshen across the street from Goshen High School. The Indian Gas station must have been a popular place to fill the gas tank. The station was built in 1927 by Walter Senmeykal in the cottage style. The building still stands. (Courtesy of the Goshen Historical Society.)

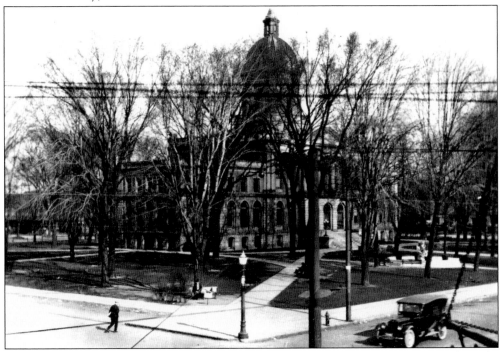

In 1912, *Neptune* was dedicated on the Elkhart County Court House Square as a gift to the city by Greek immigrant James Polezoes. Arriving in the United States from Greece in 1901, Polezoes came to Goshen in 1910. He opened a confectionery and sold candy and ice cream. The six-foot bronze-and-zinc statue was Polezoes's gift to his adopted community for helping him achieve the American dream. (Author's collection.)

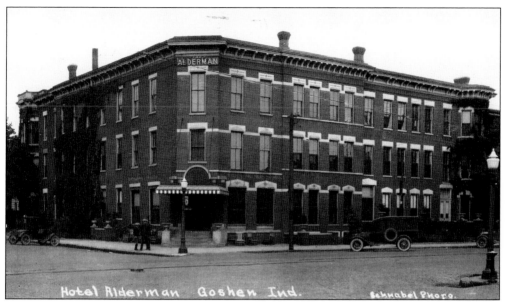

Originally operated as the Hascall Hotel, the 1924 official road guide for the Lincoln Highway included an advertisement for the Alderman Hotel. W. F. Hackett was listed as the manager. Rates were $3.50 to $4. The hotel featured running water in every room and a dining room. Over the years, the hotel included a bowling alley, and WKAM Radio rented studios in the hotel. The hotel was razed in 1966. (Courtesy of the Goshen Historical Society.)

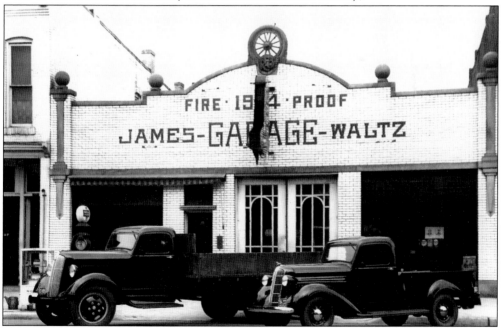

Built in 1914, this was originally the location for the REO (founded by Ransom Eli Olds) dealership and automobile garage that served travelers on Goshen's Main Street. REO was a huge supporter of good roads and announced plans to build the REO Highway to the great Lincoln Highway, connecting picturesque Michigan to the good roads of Ohio and Indiana. The business later became the James Waltz Garage. (Courtesy of the Goshen Historical Society.)

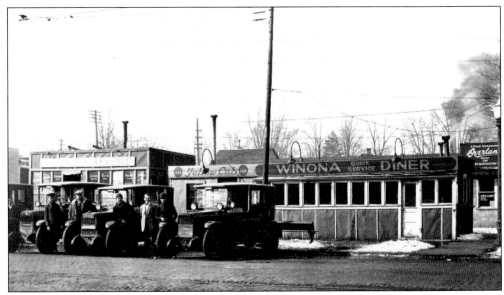

Just off Main Street, the Winona Diner served tourists along the Lincoln Highway. The Yellow Cab Company's station and the Goshen Key Shop were located on the south side of the diner, and the local Overland Auto Dealership was on the north side. The Overland dealership posted a sign in its window advertising used cars. Interurban tracks run along Main Street. (Courtesy of the Goshen Historical Society.)

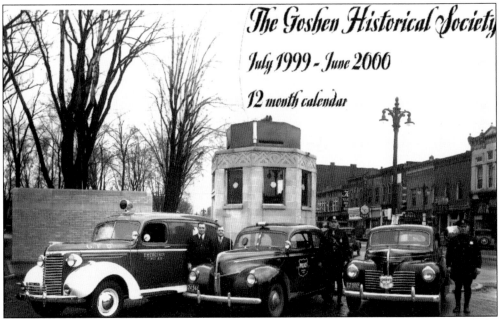

In 1939, Goshen protected the community from gangsters that traveled Indiana roads by building a police observation booth. The WPA project combined city and federal funds to build an octagonal bunker to monitor traffic along the Lincoln Highway. This route was a vital east–west thoroughfare. Goshen never saw John Dillinger, but the booth was staffed until 1969. In 1983, it became the property of the Goshen Historical Society. (Courtesy of the Goshen Historical Society.)

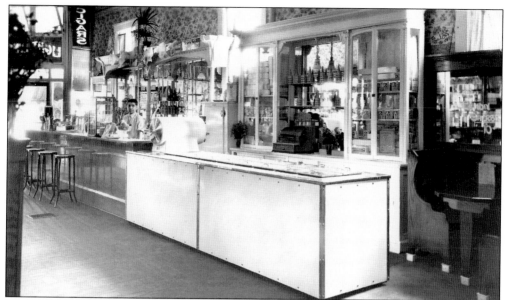

Handmade candy and soda fountain drinks stand among those cherished Goshen traditions. At the Olympia Candy Kitchen customers have been ordering cherry phosphates and green rivers for decades. Stop in to take a trip back in time and meet the family—that is the third and fourth generations of the Paflas family. The Olympia Candy Kitchen continues to create candy confections following 80-year-old recipes. (Author's collection.)

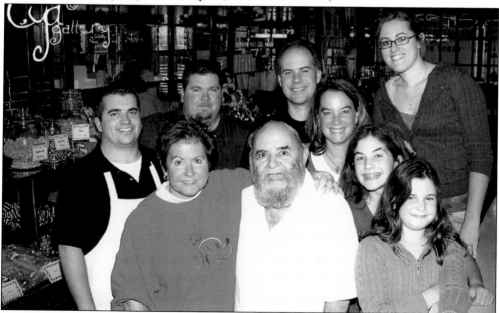

The Olympia Candy Kitchen in downtown Goshen is owned by the Paflas family. In 1912, Greek immigrant Nicholas Paflas began making his own hand-dipped chocolates and running the soda fountain the Old World way, with friendly and courteous service. In 1920, he purchased the candy kitchen and added a diner. The Olympia Candy Kitchen has remained a family business, passed down from generation to generation, and retains its Old World charm. (Courtesy of the Paflas family.)

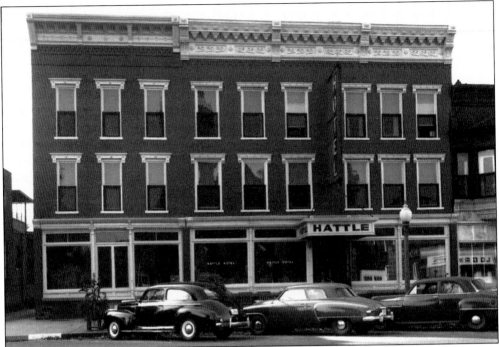

In 1924, the Lincoln Highway road guide included an advertisement for the European-style Hattle Hotel in Goshen. Daniel Getz was the proprietor. The Hattle offered rooms with baths and hot and cold water. Locals report that the hotel also had a honeymoon suite. The Hattle is located one-half block east of Main Street on Lincoln Avenue and claims to be the place where E. Bogan Noble, a hotel steward, invented and patented the first dishwasher. (Courtesy of the Goshen Historical Society.)

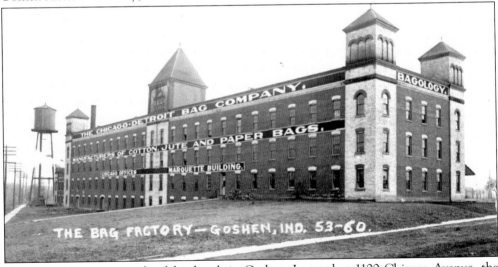

A smokestack serves as a local landmark in Goshen. Located at 1100 Chicago Avenue, the Cosmo Buttermilk Soap Company first opened for business in 1896. In 1910, it became the Chicago-Detroit Bag Company. In 1925, the company became the Chase Bag Company. The last bags were manufactured in 1975. Today the property is owned by Larion and Nancy Swartzendruber and is known as the Old Bag Factory. (Courtesy of the Goshen Historical Society.)

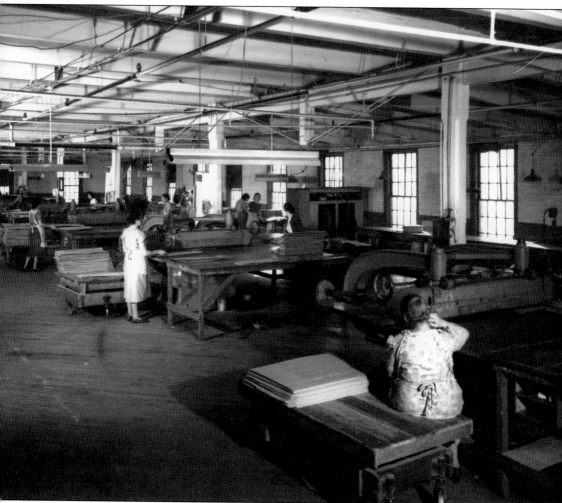

Women work at the Chicago-Detroit Bag Company in what today is the Old Bag Factory. Today the old factory is a commercial center filled with artisans and unique products including handcrafted furniture, a visual art gallery, a sculptor's studio, a candle shop, and quilt and antique shops. The Trolley Café welcomes tourists, and the concert hall provides quality entertainment on the third floor. (Courtesy of the Goshen Historical Society.)

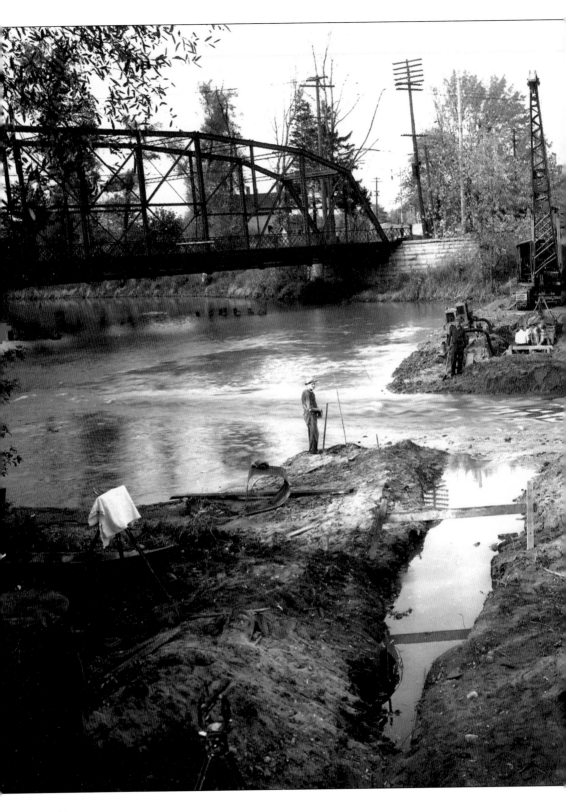

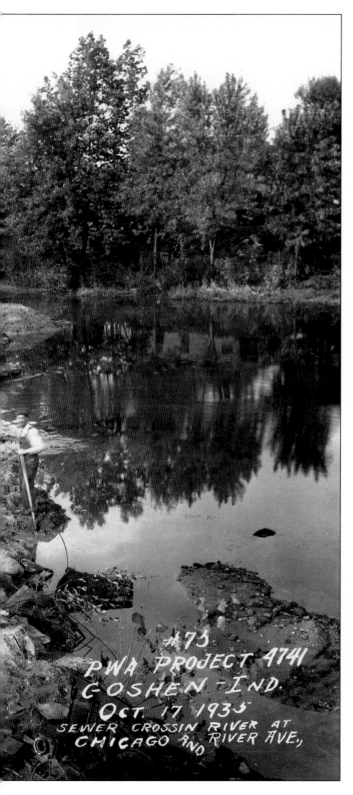

#75
PWA PROJECT 4741
GOSHEN - IND.
Oct. 17 1935
SEWER CROSSIN RIVER AT
CHICAGO AND RIVER AVE,

One of Goshen's WPA projects during the 1930s was the construction of a sewer system across the Elkhart River. The Indiana Bridge, built in 1898, is in the background. The bridge was an early alignment of the Lincoln Highway and is a portal to the Old Bag Factory shops today. This bridge is one of the most beautiful and impressive bridges in Elkhart County. The bridge is composed of 12 panels with V lacing and a complex Pennsylvania configuration making a complex geometric beauty. Extensive ornate decorative treatments on the portal and railings add to the beauty. The through nature of the bridge makes the bridge large and noticeable and the experience of crossing of the river an exciting few moments. Today the Old Bag Factory's smokestack looms large on the western bank (not shown here), marking the historic site that includes an early gas station. (Courtesy of the Goshen Historical Society.)

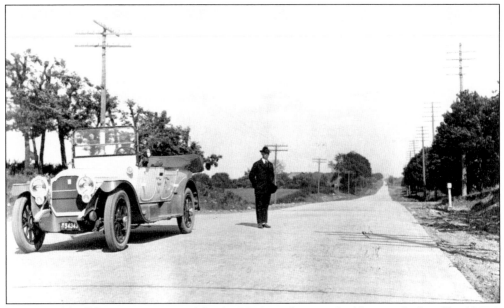

E. L. Arnold, Elkhart County consul for the LHA, is photographed here with the official LHA Packard on a new stretch of concrete that ran 21 miles long and 18 feet wide. This section of the Lincoln Highway was located in St. Joseph County, west of Elkhart. Notice the Lincoln Highway radiator emblem. (Courtesy of the LHA collection/University of Michigan.)

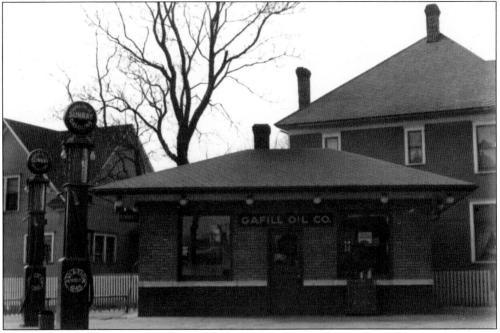

The Gafill Oil Company of Elkhart was one station in a chain of stations that were built on federal and state highways to serve travelers. Along the Lincoln Highway in Indiana, Gafill operated stations in South Bend, Elkhart, Goshen, Ligonier, Osceola, and Mishawaka. The company distributed free road maps to customers. (Courtesy of the Northern Indiana Center for History.)

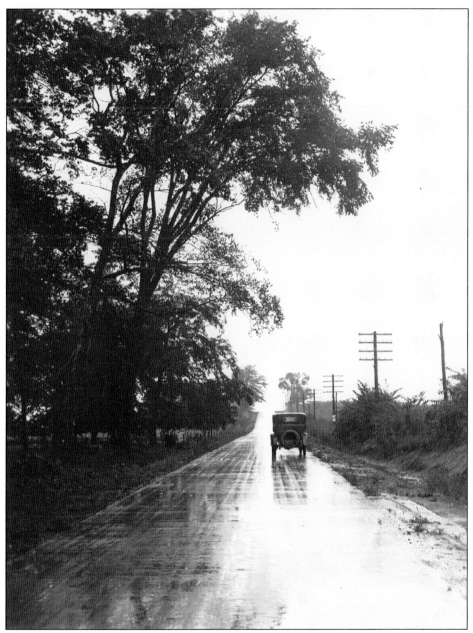

Improvements to the Lincoln Highway route were made rapidly in Indiana as compared to most states along the coast-to-coast route. This photograph captures a drive on a rainy day in Elkhart County on a good section of road in 1922. Both concrete and brick replaced gravel and macadam surfaces making travel less of a challenge. Within a decade, the Lincoln Highway in Indiana had been transformed from poor roads to state-of-the-art construction. The communities touched by the route were equally transformed as the horse gave way to the automobile. In the northern region of Indiana, agricultural enterprises and industrial manufacturers benefitted from the improved lifeline to get goods to market. Spring and fall rains that once ceased travel for long periods no longer turned the main road into a mud hole. (Courtesy of the LHA collection/University of Michigan.)

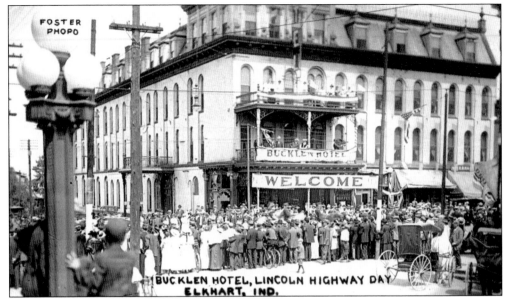

In 1915, the Bucklen Hotel in Elkhart posted a billboard south of the city advertising rooms for $2.50 to $3.50 per day. Amenities included telephone, steam heat, running water, and a dining room. G. E. Sherman was the proprietor. The Bucklen was the site for the Lincoln Highway dedication that included a large parade. Other Elkhart hotels included the Depot Hotel, the Golden Hotel, and the Kaiserhof. Nine garages advertised overnight parking for 35¢ to 50¢. (Courtesy of the Goshen Historical Society.)

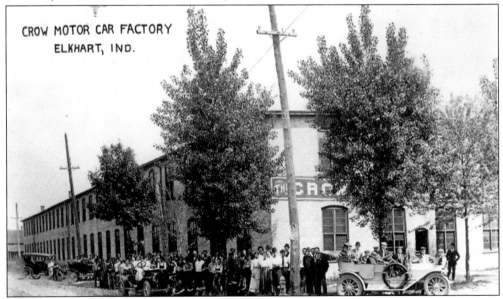

Elkhart County was fertile ground for the evolving automobile industry. An impressive number of companies manufactured road machines as early as 1900. This photograph shows the employees of the Crow Car Company displaying their automobiles. An advertisement in *Motor Age* magazine speaks of special attention paid to the cars manufactured at Crow, including counterbalanced crankshaft motors, fascinating coachwork, and custom service. A 1916 Elcar sold for $795. (Author's collection.)

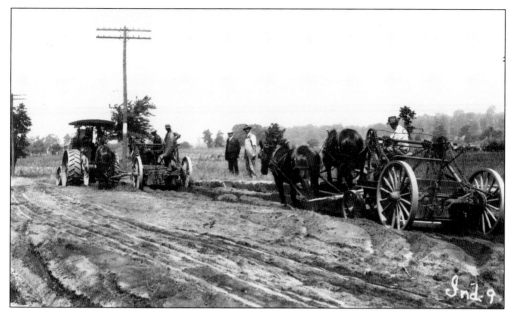

In 1918, a crew prepares the grade for concrete along the Lincoln Highway in Elkhart County. A steam tractor and horse teams provide the power. In 1916, Albert A. Rieth of Goshen established the Rieth-Riley Construction Company. The company has built many roads across Indiana and has become one of the largest road and bridge construction companies in the nation. The company constructed part of the original Lincoln Highway across Indiana. (Courtesy of the LHA collection/University of Michigan.)

This work crew is busy at work constructing the last section of the Lincoln Highway between the cities of Elkhart and Osceola. This photograph was taken in 1918 by Lincoln Highway officials inspecting progress along the route. The concrete paving machine is being used to pour the main road, but a horse team is still in business landscaping the grade. (Courtesy of the LHA collection/University of Michigan.)

The U.S. Tire Company constructed a series of large billboards across the Lincoln Highway in 1926. The billboards were advertisements for tires, but they were also mini history lessons that focused on historical and Native American themes. U.S. Tire built billboards in Elkhart, Goshen, Ligonier, Churubusco, and Fort Wayne. (Courtesy of the LHA collection/University of Michigan.)

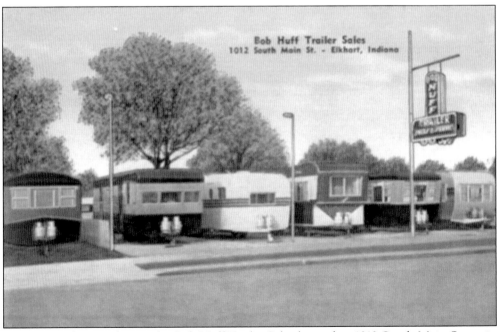

This postcard image depicts the Bob Huff Trailer Sales located at 1012 South Main Street in Elkhart. Elkhart's trailer and motor home manufacturers made Elkhart County famous worldwide as a leading producer of recreational vehicles. (Courtesy of Russell Rein.)

Five

TO AND AROUND
THE BEND

St. Joseph County was greatly impacted by Indiana's visionary Carl Fisher. His highways, the Dixie and the Lincoln, meet in the heart of downtown South Bend and their intersecting paths did much to promote commerce and tourism. The routes made South Bend–Mishawaka a key stopping point for travelers going east–west or north–south and also had significant impacts on Osceola and New Carlisle.

When the Lincoln Highway was celebrated on October 31, 1913, John M. Studebaker spoke for the South Bend section of the road at a bonfire that lit up the night skies at Springbrook Park at the edge of the twin cities. The Studebaker Corporation made donations to the LHA to support the cause. Studebaker published one of the first automobile road maps that marked the roads of Indiana. The coming of good roads was the beginning of something bigger than itself, and local leaders had a sense of it before it arrived.

In 1914, the City of South Bend made plans to erect memorial arches to Abraham Lincoln over the Lincoln Highway at the east and west entrances to the city. The arches were never built, and although images of the arches were found in the archives at the University of Michigan, a review of the South Bend City Council meeting minutes failed to reveal any further information. A bronze plaque incorporating the 1914 memorial arch design honoring Abraham Lincoln and Carl Fisher will be placed at the intersection of the Lincoln and the Dixie Highways in downtown South Bend in 2009. The plaque is a project planned by the Indiana Abraham Lincoln Bicentennial Commission, the City of South Bend, and the Indiana Lincoln Highway Association.

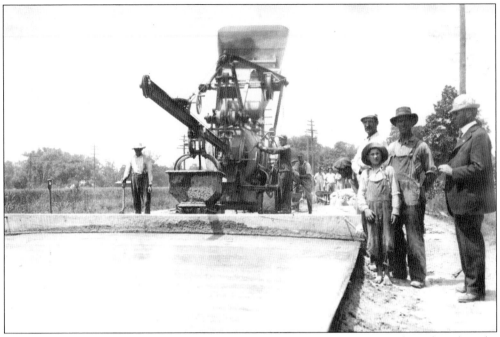

This photograph shows the last gap of the Lincoln Highway between Osceola and Mishawaka being poured with new concrete. As the automotive age hit the village of Osceola in 1915, the population was 250. Gas was 11¢ a gallon, there were four businesses listed in the Lincoln Highway road guide, and 10 automobiles were owned by local residents. (Courtesy of the Northern Indiana Center for History.)

Mishawaka is located on the St. Joseph River and is the twin city of South Bend. Its nickname is "the Princess City" with the name taken from a mythical Native American figure. The city's history is filled with industrial giants such as Dodge, Perkins Windmill Company, Kamm Brewery, and the Mishawaka Woolen and Rubber Company. Mishawaka is filled with European ethnic neighborhoods and today is an upscale shopping district. (Courtesy of the Northern Indiana Center for History.)

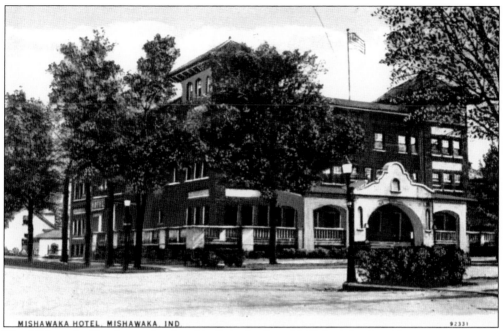

MISHAWAKA HOTEL, MISHAWAKA IND.

The Mishawaka Hotel was a fine hotel built in the Spanish Colonial style with prominent towers on its corners. The restaurant featured one of Chicago's best chefs. All rooms faced the street. The hotel included broad, shady porches, a bowling alley, billiards, lavishly furnished lounges, and café service. Rates were $2 to $4 per day. Interurban service made the hotel an excellent place for businessmen to conduct business. (Courtesy of the Hannah Lindahl Children's Museum.)

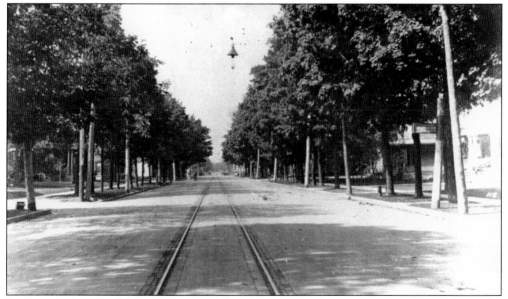

In 1924, the Mishawaka Post Office served as the control station on the Lincoln Highway. The population was 15,195. There was one hotel listed. The speed limit was 10 miles per hour and enforced. Mishawaka had three banks, three railroads, and one trolley. The streets were paved in brick with trolley lines running down the center. (Courtesy of the Northern Indiana Center for History.)

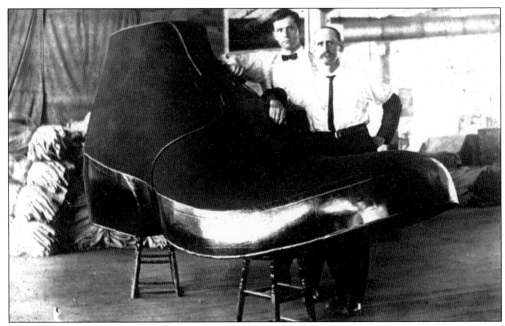

The Mishawaka Woolen and Rubber Company (later Ball Band, then Uniroyal) set up manufacturing plants on the banks of the St. Joseph River. Ball Band made rubber garments and was hit by a major strike in 1931 but flourished in the 1940s, finally closing in 1997 in the face of cheaper imports. The city of Mishawaka's diverse population includes large Italian, German, and Belgian settlements dating from the late 19th century. (Courtesy of the Northern Indiana Center for History.)

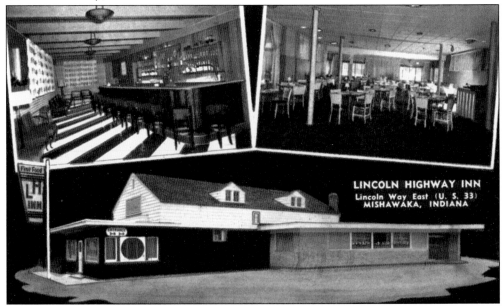

Located at the eastern edge of Mishawaka, the Lincoln Highway Inn provided motel rooms, a full dining room and bar, as well as live entertainment to travelers and locals alike. The restaurant was well known for its special Lincoln Highway Inn dressing, which was a variation of Thousand Island dressing. (Courtesy of the Northern Indiana Center for History.)

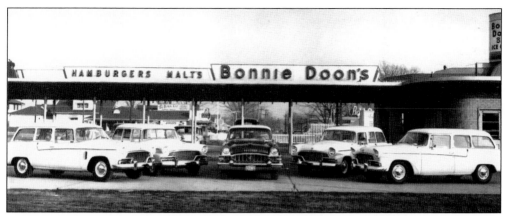

Bonnie Doon's carhops, neon lights, music, and summer nights have made this chain of locally owned drive-ins a destination. The Muldoon brothers make ice cream in a wide variety of flavors at 109 East Fourth Street in Mishawaka. In the 1950s, Bonnie Doon's advertised banana boats made with vanilla, strawberry, and chocolate ice cream served with strawberry sauce, pineapple sauce, chopped nuts, whipped cream, and a cherry. (Courtesy of the Northern Indiana Center for History.)

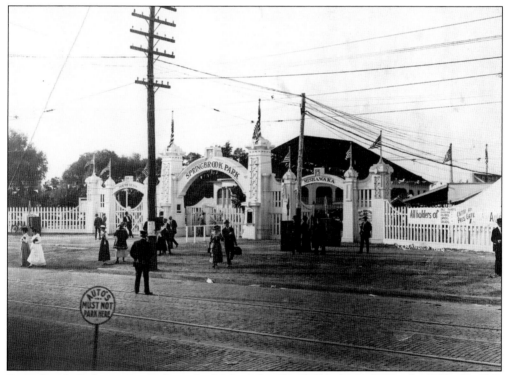

Springbrook Park was located on the Mishawaka–South Bend city limits. In 1919, the U.S. military convoy camped here overnight on its way to San Francisco on the Lincoln Highway. The park was home to South Bend baseball from 1896 until the 1950s and the home field for the South Bend Blue Sox—an all-American women's team during World War II. (Courtesy of the Northern Indiana Center for History.)

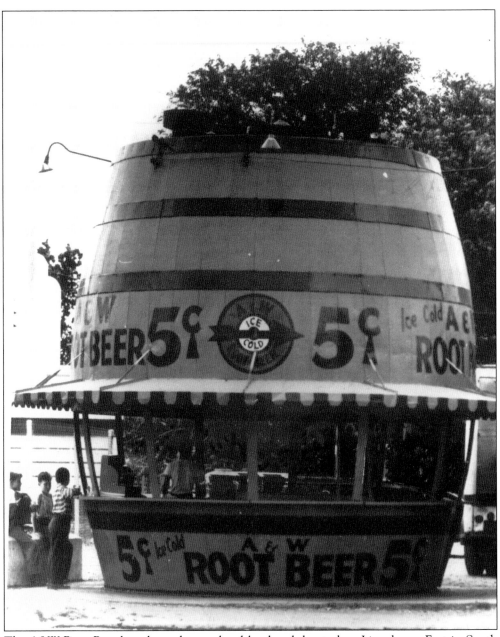

The A&W Root Beer barrel stand was a local landmark located on Lincolnway East in South Bend near the old Sample Street bridge. The stand was just across the St. Joseph River from the very popular South Bend Farmer's Market. In 1933, the creamy beverage company had over 170 franchised outlets operating in the Midwest and West and sold A&W Root Beer concentrate exclusively to each franchise operator. In the early 1960s, the root beer stand became a drive-in restaurant. It was one of over 2,000 at that time. The drive-in featured carhops and inside seating. The barrel was torn down. The Lincolnway East and Sample Street bridge overpass was built at the same time and significantly changed the landscape along the corridor. There was also a root beer stand in Plymouth (on West Jefferson Street) on the 1926 Lincoln Highway alignment. (Courtesy of the Northern Indiana Center for History.)

BIRD'S EYE VIEW, SHOWING LINCOLN WAY EAST, ST. JOE RIVER AND HOWARD PARK, SOUTH BEND, IND.

This postcard image captures Lincolnway East in South Bend during the 1920s. The route was once part of U.S. 20 and the coast-to-coast Lincoln Highway. The street was once known as Vistula Avenue, but when the Lincoln Highway was established the name was changed to Lincolnway East. The bordering neighborhoods were established between 1907 and 1923. (Courtesy of the Northern Indiana Center for History.)

The Jefferson Street bridge was built in 1905 and became the main feeder bridge onto the Lincoln Highway in downtown South Bend. It was one of the first bridges across the St. Joseph River to employ the Melan arch system during the city beautiful movement. (Courtesy of Greg Koehler.)

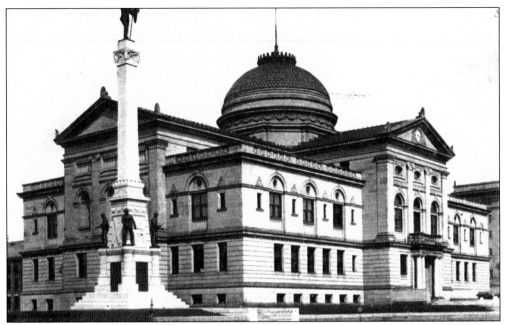

St. Joseph County's courthouse is located at the intersection of Washington and Main Streets on the Lincoln Highway's 1926 route. Built in 1897 in the classical revival style, the rotunda paintings depict French explorer René-Robert Cavelier, Sieur de La Salle, at the portage. Public restrooms were located at the southeast corner of this intersection in the 1920s, and the Lincoln Highway control station was located across the street at the Oliver Hotel. (Courtesy of the Northern Indiana Center for History.)

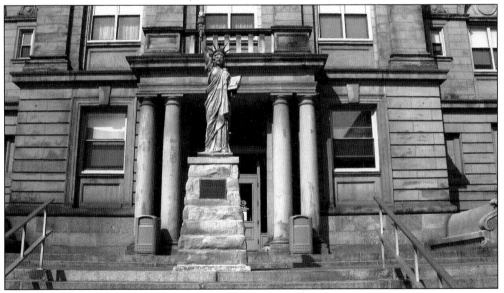

In 1950, over 200 replicas of the Statue of Liberty were placed in 39 states by Boy Scouts in celebration of their 40th anniversary. This one was placed at the St. Joseph County Court House in South Bend. Only one other Lady Liberty replica is located on Indiana's Lincoln Highway. It stands on the 1926 alignment in Plymouth at the Marshall County Court House. (Author's collection.)

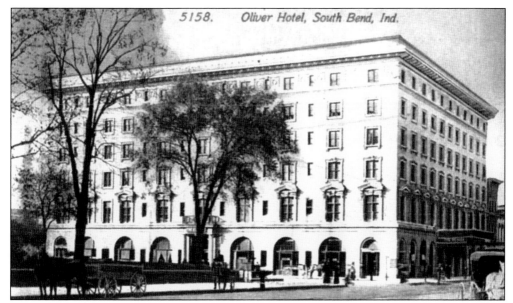

5158. Oliver Hotel, South Bend, Ind.

James Oliver built the world-famous Oliver Chilled Plow Company and the six-story Oliver Hotel to impress visitors to the city. The Oliver Hotel was the Lincoln Highway control station and was advertised as "the best in the West." A round of golf at the Chain-O-Lakes Golf Course came with an overnight stay. It was located at the northwest corner of Main and Washington Streets in South Bend. (Courtesy of the Northern Indiana Center for History.)

The Oliver Hotel in South Bend sold china souvenir plates during the touring year of 1915–1916. This was the year when travelers were making their journey across the United States to attend the Panama-Pacific International Exposition in San Francisco. The plate honors Abraham Lincoln and promotes the Oliver as a fine hotel. This plate is from the collection of the Northern Indiana Center for History. (Author's collection.)

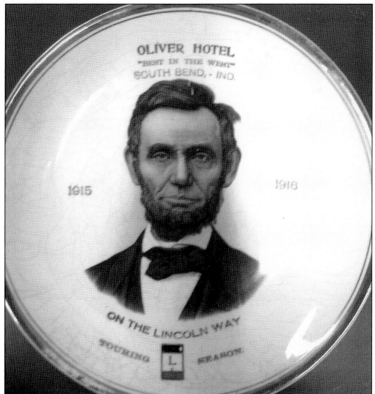

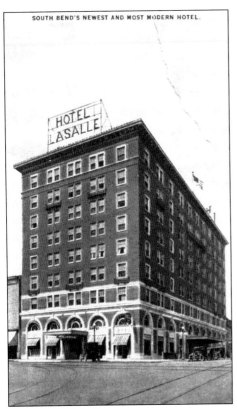

Located at 237 North Michigan Street on the Dixie and Lincoln Highways, the Hotel LaSalle stood at the terminus of the South Shore Electric interurban that ran between Randolph Street in Chicago and South Bend. The LaSalle was built in 1921 and became a landmark and a transportation hub for travelers and immigrants arriving in South Bend. Serving the nation as the last interurban, the Chicago South Shore and South Bend Railroad (CSS&SB) electric commuter trains still run between South Bend and Chicago. (Courtesy of the Northern Indiana Center for History.)

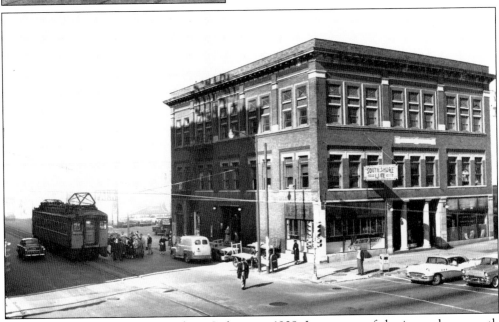

The CSS&SB began serving northern Indiana in 1908. It was part of the interurban growth that was beginning across the United States. Unlike streetcars, the South Shore line operated on a high-voltage system that allowed for the use of standard railroad gauge equipment. The line handled both freight and passengers. (Courtesy of the Northern Indiana Center for History.)

In 1938, the Bonnie Doon Corporation was founded by brothers Herman and Andrew Muldoon. South Bend's first drive-in was located at the corner of LaSalle and Lafayette Streets on the Lincoln Highway. Carhops posed for photographs even before the restaurant sign was in place. Ice cream and Bonnie Doon drive-ins became synonymous in the twin cities of South Bend and Mishawaka. (Courtesy of the Northern Indiana Center for History.)

In the 1950s, business was booming at Bonnie Doon's on Lincolnway West in South Bend. Customers placed orders over a microphone and rolled their car windows up just enough to hold the food and drink tray. The drive-ins became popular hangouts for teens, but families frequented here in great numbers. Locals recall cruising to the drive-in on hot summer nights for shakes, root beer floats, and hamburgers. (Courtesy of the Northern Indiana Center for History.)

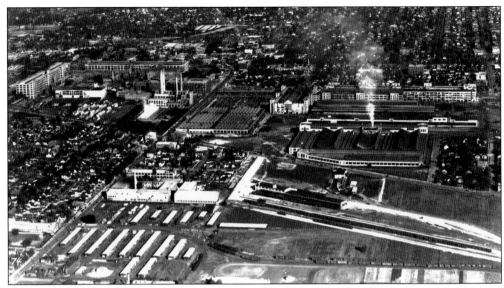

John M. Studebaker was an avid supporter of the LHA. In 1915, when the LHA was planning to produce a film about the highway to promote the road, the Studebaker Corporation furnished a car that was used by J. Meinzinger, the project's research engineer, and R. C. Sackett, a publicity man. South Bend's and Mishawaka's industries made the area a leading industrial center. Studebaker's successful transition from wagon and buggy manufacturing to the gasoline-powered automobile had a major impact on the quality of life in St. Joseph County. In 1910, the company sold 22,555 cars and in 1913 it sold 114,000. In 1920, Studebaker built a new plant in South Bend moving automobile production to Indiana. The South Bend plants employed thousands and stretched across the south side of the town. These photographs show plant No. 1 and plant No. 2 in the mid-1920s. (Courtesy of the Northern Indiana Center for History.)

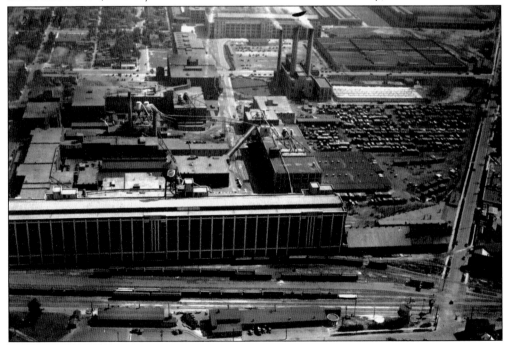

The Studebaker brothers—founders of what would become the Studebaker Corporation—are shown here, from left to right, (first row) Clem, Henry, and John M.; (second row) Peter and Jacob Studebaker. The Studebaker Corporation, or simply Studebaker, was a United States wagon and automobile manufacturer based in South Bend. Studebaker entered the automotive business in 1902. The company was acquired in 1954 by Packard Motor Car Company of Detroit. (Courtesy of the Studebaker National Museum.)

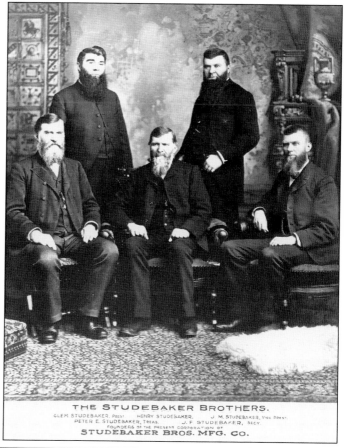

THE STUDEBAKER BROTHERS.
CLEM STUDEBAKER, Prest. HENRY STUDEBAKER. J. M. STUDEBAKER, Vice Prest.
PETER E. STUDEBAKER, Treas. J. F. STUDEBAKER, Secy.
FOUNDERS OF THE PRESENT CORPORATION OF
STUDEBAKER BROS. MFG. CO.

In 1931, the Studebaker Corporation produced the largest car in the world and parked it at the entrance to its 800-acre outdoor laboratory or proving grounds near New Carlisle. Several years later, the company planted pine trees to create the largest living sign for the Guinness World Records. Today a portion of the property is a county park. The Bosch Corporation operates the proving grounds to test brakes. (Courtesy of the Studebaker National Museum.)

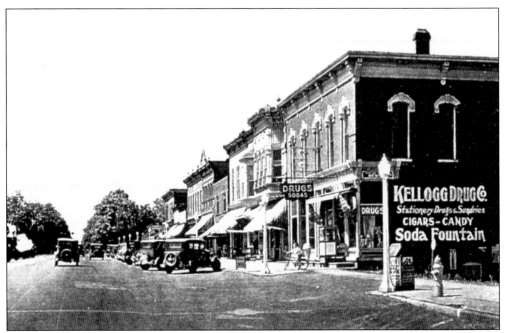

When the Lincoln Highway route was announced through New Carlisle the town council voted to place entrance signs at the city limits. New Carlisle was 802 miles from New York City and 2,529 miles from San Francisco. The post office served as the control station. There was one hotel and the White Garage. The highway was concrete and brick by 1924. These postcard images provide glimpses into the town's history and show the main business block and the laying of pavers. The Lincoln Highway route through New Carlisle was originally the Michigan Road, which linked Madison, Indiana, to Lake Michigan at Michigan City. In 1907, two interurban lines connected New Carlisle to South Bend and Chicago. Today the business block is listed on the National Register of Historic Places. (Courtesy of Historic New Carlisle.)

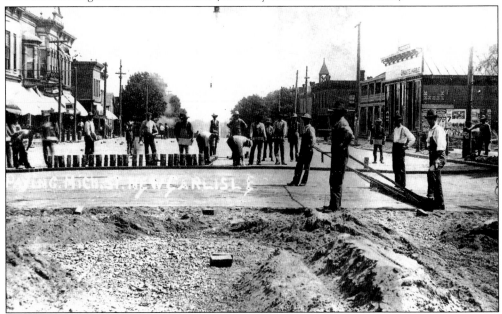

Ed Harris served as New Carlisle's first Lincoln Highway consul and did much to promote the town and the Lincoln Highway. The Harris family ran a grocery business in downtown New Carlisle for 36 years. Following Harris's death, James Proud became the local consul. (Courtesy of the LHA collection/University of Michigan.)

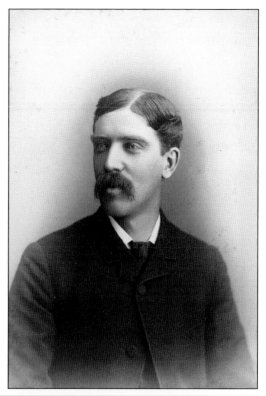

Ed Harris's wife, Carrie Service, was a daughter of Jeremiah Service, who built the grand Italianate on the hill overlooking the railroad crossing at the eastern edge of New Carlisle. Harris and his wife lived on Michigan Street (the Lincoln Highway). Their home is now part of the national register district. (Author's collection.)

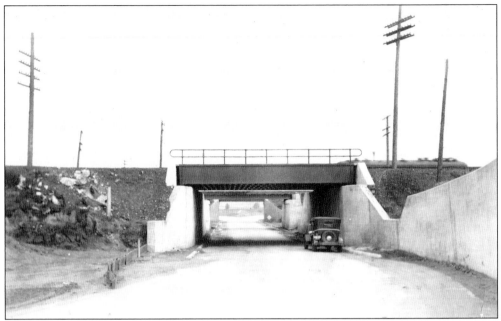

The "Death Crossing" was a grade with several tracks: the New York Central Railroad, the Northern Indiana Railroad, and the CSS&SB. The grade separation was completed in 1924 after a long battle over cost. As the nation's only electric interurban still in existence, the South Shore continues to provide service between Chicago and South Bend with stops in Hudson Lake and the South Bend Regional Airport. (Courtesy of the University of Michigan.)

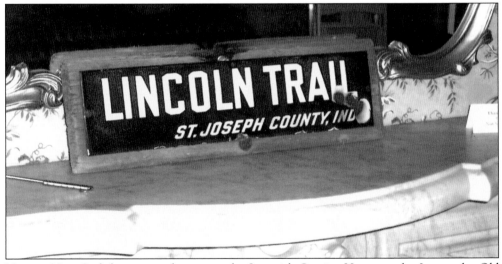

Historic New Carlisle owns and operates the Jeremiah Service House as the Inn at the Old Republic on the hill overlooking the famous railroad viaduct on the Lincoln Highway. The Lincoln Highway is named Michigan Street. A museum on New Carlisle and Hudson Lake history is located in the servant's quarters of the historic home. Among the artifacts is an old road sign that reads "Lincoln Trail / St. Joseph County, Ind." The Lincoln Highway through Olive Township was marked as the Lincoln Trail and continued to carry that designation even after it became U.S. 20 in 1926. The main part of the historic Service house serves travelers today as a beautiful bed-and-breakfast. (Author's collection.)

Six

THROUGH THE DOOR

When French fur traders arrived in northwest Indiana during the 1600s, a natural opening through the forest served as a gateway to the prairies beyond. They called this opening La Porte, meaning "the door," from which the county received its name. La Porte County became the second-largest county in geographic area (608 square miles) in Indiana and was organized in 1832.

Fur traders and early settlers used the Sauk Trail that had been created by Native Americans who lived and traveled the area along the Lake Michigan shoreline. This trail ran from Lake Erie to Rock Island on the Mississippi River.

Much of the force behind the area's early settlement was due to the creation of the Michigan Road that ran from Madison on the Ohio River north to South Bend and then west to Michigan City on Lake Michigan. This route avoided the million-acre Kankakee Marsh that lay to the southwest of South Bend and stretched southwest to Kankakee, Illinois. The Michigan Road was constructed on land ceded to the State of Indiana in 1826 by the Potawatomi Indians.

The section of the Michigan Road between South Bend and the city of La Porte was designated as the Lincoln Highway in 1913. From La Porte, the Lincoln Highway turned southwest on what became State Road 2 and ran through Westville and then to Valparaiso. This area was one of the last sections in Indiana to be paved along the Lincoln Highway.

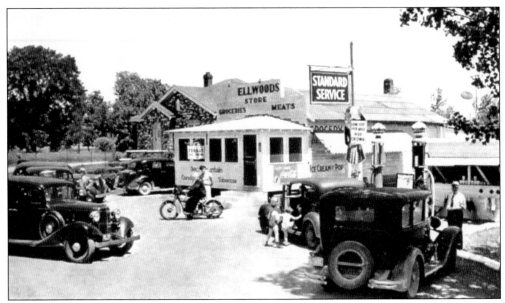

In the 1920s, Hudson Lake Casino was a gambling destination that drew tourists from Chicago via the South Shore Electric interurban line. Big bands played to large crowds and included Guy Lombardo's Royal Canadians. Elwood's Store at Hudson Lake offered tourists many amenities from "low cost per mile Red Crown" gasoline at the Standard station to groceries and meat at the general store; adults and children flocked to Elwood's. (Courtesy of Historic New Carlisle.)

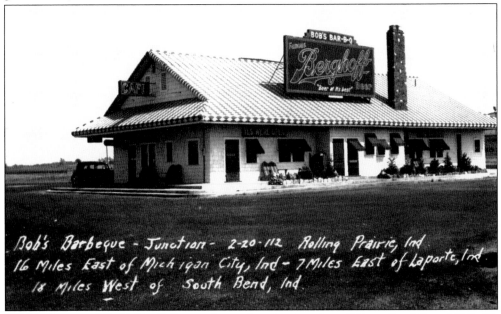

Wiley's Camp and Bob's Bar-B-Q were located at the junction of State Road 2 and U.S. 20. Wiley's was listed as "Indiana's finest modern equipped cabins and restaurant." Bob's was open 24 hours. In the 1940s, Bob's advertised its modern motel court that featured Beauty Rest mattresses. Today travelers stop at the restaurant that is renamed Jennie Rae's. There are no overnight accommodations. Jennie Rae's slogan is "where our family meets yours." (Courtesy of Russell Rein.)

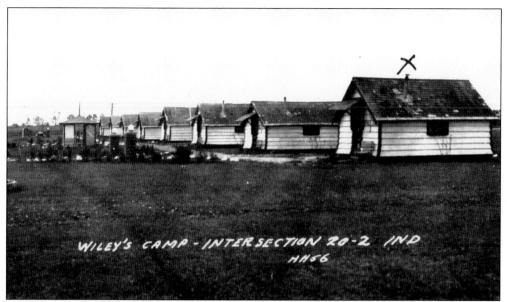

Wiley's Camp was located west of New Carlisle at U.S. 20 and State Road 2 near Rolling Prairie. At the time of this photograph, Wiley's Camp had eight cabins. Guest accommodations included a water pump, picnic tables, and separate privies for men and women. Bob's Bar-B-Q was located on the east side of the property. The main drive was marked with stones and entrance pillars. (Courtesy of the La Porte County Historical Society.)

In June 1915, the Lincoln Highway was dedicated across Indiana. Lincoln Highway officials, politicians, and local organizations participated in long parades and speech making. The La Porte parade included the official LHA car with a movie camera stand on the running board and lettering indicating the distance from New York to San Francisco. Carl Fisher, founder of the Lincoln Highway and the Indianapolis Motor Speedway, came to La Porte for the parade. (Courtesy of the La Porte County Historical Society.)

In 1926, Lincolnway through downtown La Porte passes the La Porte Theatre, which is playing Rin Tin Tin in *A Hero of the Big Snows*. There is a tourist home sign on the left advertising rooms for tourists. The Lincoln Hotel and the J. C. Penney store are on the right side of the street. Trolley tracks run down the center of the street. The courthouse tower is in the background. (Courtesy of the La Porte County Historical Society.)

This photograph captures a parade in downtown La Porte on Lincolnway in the 1920s. Posted on the streetlight pole is a Lincoln Highway porcelain sign that appears to be one manufactured by the Cutter Light Company of South Bend. Sears, Roebuck and Company and the Lincoln Hotel are in the background. (Courtesy of the La Porte County Historical Society.)

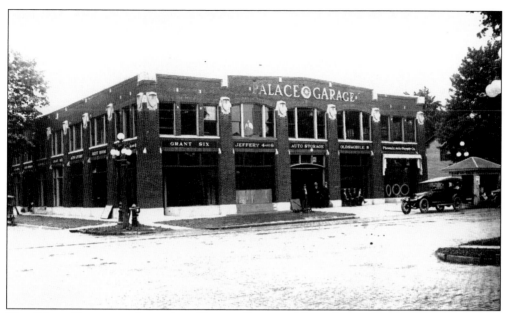

The Palace Garage was located at Chicago Street and Lincolnway West in La Porte. It was built by Carl Peterling in 1916. The garage sold gasoline at the curb that was pumped from an official Bowser Lincoln Highway pump. The garage sold new automobiles and provided an automobile storage service. In 1918, the upper floor was rented to the E. A. Couturier Band Instrument Company that manufactured brass and woodwind instruments. (Courtesy of the La Porte County Historical Society.)

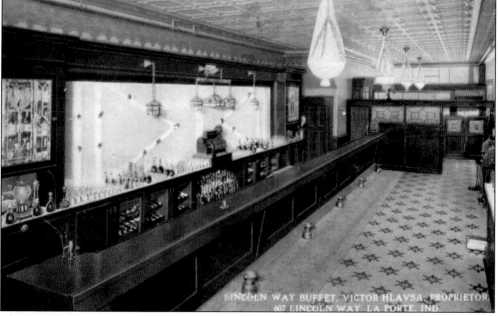

The Lincoln Way Buffet was located at 607 Lincolnway in downtown La Porte. Victor Hlavsa was the proprietor. The buffet was decorated in the arts and crafts style and provided customers with a fully stocked bar and brass spittoons for spitting convenience. Today this is the location of B&J's American Cafe. (Author's collection.)

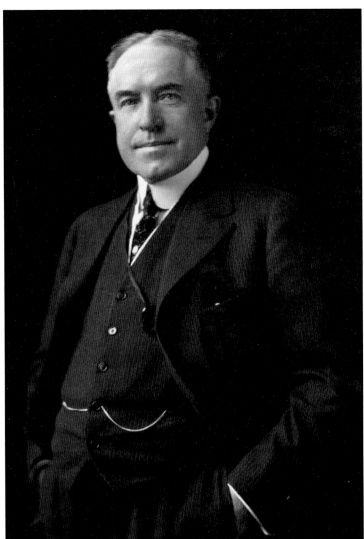

Judge John C. Richter served as judge on the La Porte Circuit Court for 18 years. He also served as La Porte's Lincoln Highway local consul. Consuls provided information to the LHA's office in Detroit and shared information from the office with travelers and the public. The consul in Westville was I. N. Plant, who owned the hardware store. In Valparaiso the county consul was Charles Wark, also a hardware store owner. The local consul in Valparaiso was E. D. Hodges, who worked for the Pennsylvania Railroad. (Courtesy of the LHA collection/University of Michigan.)

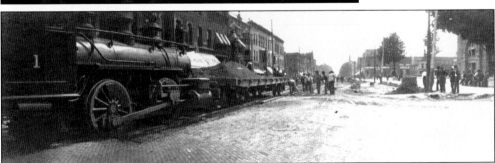

The city of La Porte laid pavers along Lincolnway by laying a spur line along the corridor to bring in the pavers and the sand for the roadbed. This scene is looking west on South Main Street (Lincoln Way) near the La Porte County Court House. In the early 1900s, brick was laid on many of the streets, replacing old blocks. The pavers were made locally. (Courtesy of the La Porte County Historical Society.)

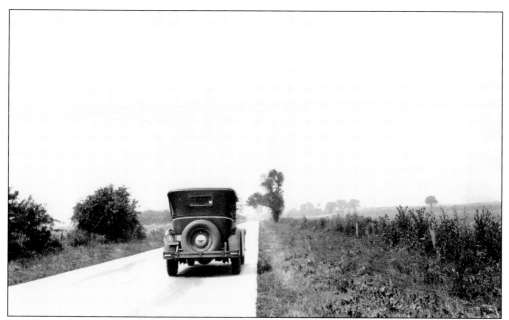

By 1926, this stretch of the Lincoln Highway was paved in new concrete. The LHA's official car was out inspecting recent improvements. The car is stopped in this rural area of La Porte County two miles west of La Porte. (Courtesy of the LHA collection/University of Michigan.)

Westville is a farming town located at the junction of State Road 2 (the Lincoln Highway) and U.S. 421. This aerial photograph shows the town's water tower and the north–south path of U.S. 421. The Lincoln Highway curves following a southwesterly direction out of town. Westville is 10 minutes south of Michigan City and 15 minutes east of Valparaiso. (Courtesy of the La Porte County Historical Society.)

CONWAY COURT
"Where 6 And You Meet 2"
WESTVILLE, INDIANA

Conway Court was located at the intersection of U.S. 6 and State Road 2 between Westville and Valparaiso. According to the 1924 Lincoln Highway road guide, Westville had a population of 500, one hotel, automobile garages, a bank, and a newspaper. (Courtesy of Russell Rein.)

While most of the Lincoln Highway across northern Indiana had been upgraded to poured concrete and landscaped berms, the Lincoln Highway near Westville in Porter County continued to be dry macadam into the 1920s. In 1924, the Lincoln Highway between La Porte and Valparaiso was macadam. (Courtesy of the LHA collection/University of Michigan.)

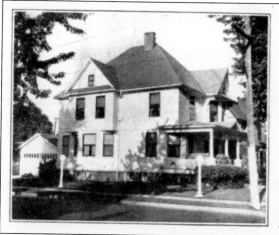

Rowland's Tourist Hotel served travelers along the Lincoln Highway in Valparaiso. Tourist homes became a popular alternative for tourists not wishing to stay in the larger and more expensive hotels in cities. In 1924, there were three hotels and a tourist camp built by the local Kiwanis Club. Tourist homes provided services where they may not have been available otherwise and were popular among women traveling alone. (Courtesy of Russell Rein.)

This is a Dunlap's Tourist Camp advertisement. (Courtesy of Russell Rein.)

YOUR TELEPHONE CALL IS OUR SELF-STARTER

INSTANT SERVICE WRECKING SERVICE

This is an advertisement from Downing's Auto Shop. (Courtesy of Russell Rein.)

Here's to the Ford; the jolly old
 thing
Has a motor as large as a com-
 mon clock spring;
Is full of gears, bushings, bearings
 and wheels;
Has a crank as dangerous as Mule
 Maud's heels.
She's very frisky but safe to drive;
On fresh gasoline she seems to
 thrive;
She eats the road, but not the
 dust—
It's possible to pass her if pass you
 must.
But watch your foot, and don't
 reel or rock,
Or you'll need the assistance of old
 Friend

DOC
PHONE 348
GEO. DOWNING
Ignition and Auto Repairing
Main, LaPorte and Garfield
VALPARAISO, IND.

George "Doc" Downing used this little
poem to promote his business in Valparaiso.
(Courtesy of Russell Rein.)

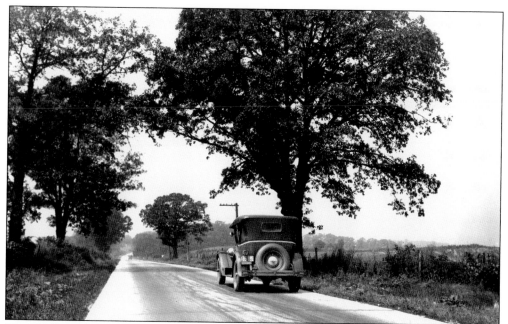

The LHA's Packard travels between Merrillville and Deep River checking road conditions. In 1918, the *Chicago Daily Times* reported on road conditions from New York to San Francisco. Travelers were warned about detours, maintenance issues, heavy traffic, road closures, and rough driving conditions. Indiana was reported in good condition with no detours of any extent. Hoosiers were ahead of the game. (Courtesy of the LHA collection/University of Michigan.)

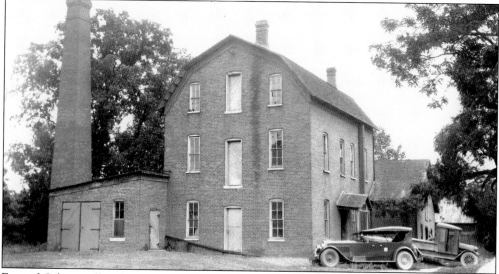

East of Schererville, the road name changes several times on the way to Merrillville. The Lincoln Highway passes through the Deep River County Park and the 19th-century Wood's Historic Grist Mill. Wheat and corn are still ground there. The second floor displays a one-room school and general store, and the third floor has a museum. Over the river is the home of the Deep River Grinders—a "vintage" baseball team. A sign reads, "Upon this field the game is played according to the original 33 rules of baseball adopted in 1858." (Courtesy of the LHA collection/University of Michigan.)

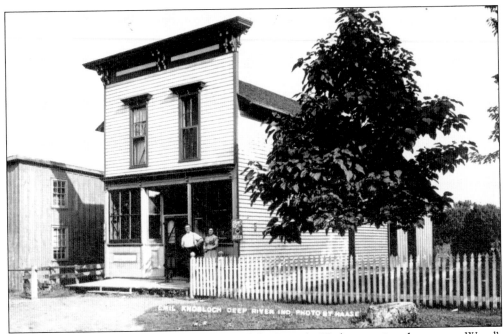

In Lake County, travelers in the early days of the Lincoln Highway enjoyed a stop at Wood's mill in Deep River. In 1924, Deep River offered gas, oil, and a telephone to motorists. The population was 60 and there were no overnight accommodations. The earlier dirt road had been replaced by concrete construction and offered a picture-perfect tree-lined drive. Today staff members welcome tourists and locals at the Lake County Visitor Center and Gift Shop located at 9410 Old Lincoln Highway. The area is part of the Lake County Parks system and hosts vintage baseball games in a field near the old millpond. (Courtesy of Russell Rein.)

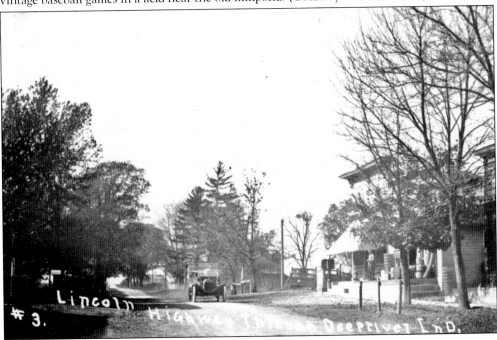

Seven

IDEALLY SPEAKING

By 1920, the federal government was spending money on roads but lacked road standards. Ahead of their time, LHA leaders had the grand ambition of creating attractive, comfortable coast-to-coast highways. They promoted beautification of roadways and quality engineering and construction standards with the tourists' experience in mind. In the years between 1913 and 1928, the LHA led by example. Never intending to actually build roads, the LHA proposed a good idea, solicited support from automobile-related manufacturers, put up signs, printed road guides, and built a short demonstration of an ideal highway.

Approximately one and one-third miles long, the Ideal Section used state-of-the-art materials, engineering design, landscaping, and lighting. Made of concrete 10 inches thick and 40 feet wide, it was one of the nation's first four-lane highways.

The LHA hired the nationally known landscape architect Jens Jensen to create the landscape plan for the demonstration, with footpaths for pedestrians, roadside plantings using native plant materials, shade trees, and the natural setting of the highway to enhance the travelers' experience. The Ideal Section attracted the attention and study of highway authorities across the nation. Henry C. Ostermann, who had worked tirelessly for the Lincoln Highway as its vice president and field secretary, died in an automobile accident on the Lincoln Highway in Iowa in 1920. In 1926, the Ideal Section was selected as the ideal place for a memorial to Ostermann. The memorial, a bench built of Indiana limestone, includes a bronze plaque paying tribute to Ostermann's accomplishments. It is an interesting historical site, but be careful if stopping to read the markers!

If it were not so dangerous to stop, a small portion of U.S. 30 east of Dyer would be a fascinating reminder of a time when concrete highways were not a commonplace utility taken for granted today. Current access to the monument is nearly impossible.

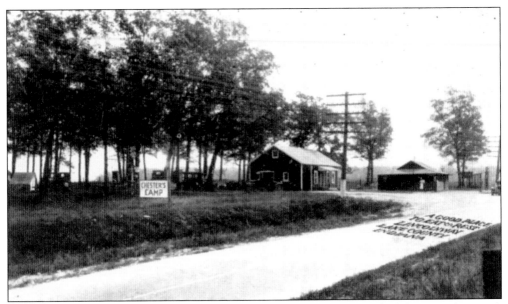

With improved roads and reliable automobiles, automobile camping had become America's favorite pastime by 1925. These real-photo postcards show Chester's Camp in Lake County on the Lincoln Highway. The camp offered automobile campers shaded campsites near the road. The barbecue chef poses to have his photograph taken in front of the Dixie barbecue stand. Tourists could fill up their gas tanks and oil reserves before heading on down the road. The photograph shows a family relaxing and someone shooting a few hoops. Chester's advertised the camp as "a good place to eat and rest." (Courtesy of Russell Rein.)

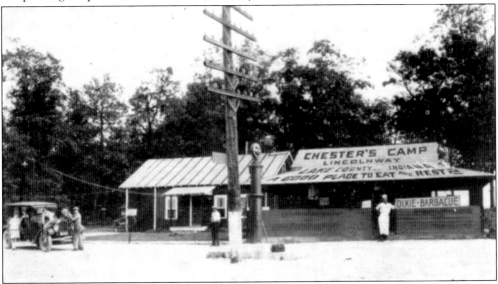

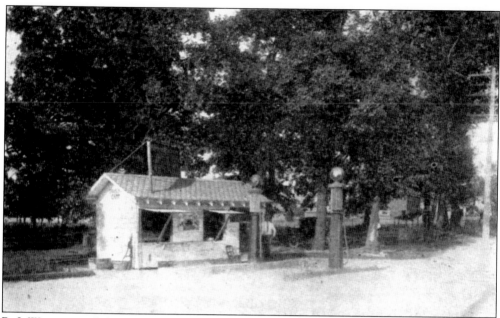

R. J. Wyatt owned the Lincoln Rest Tourist Camp in Merrillville. The tourist camp appears to have a crudely built main building with window panels that pushed out and were propped up with wood support. The island included twin gas pumps. The camp advertised electric lights, restrooms, and even barbecue. Cabins were available for rent. The camp was located at Lincoln Highway and State Road 8. (Courtesy of Russell Rein.)

MAILING CARD

Place
Stamp
Here

LINCOLN REST
TOURIST CAMP

Cabins, Rest Rooms,
Barbecue,
Gasoline, Oil,
Electric Lights,
Water

Lincoln Highway and
State Road 8
State Approved Camp

Merrillville, Indiana

R. J. WYATT, Proprietor

Immediately East of Dyer in Lake County, the LHA built a section of state-of-the-art highway called the Ideal Section. This photograph captures the area of highway prior to the Ideal Section being constructed. After an exhaustive study of other suggested locations, the LHA directors

decided on this location near Chicago where there would be great contrast between existing roads and the projected ideal construction as well as maximum traffic that would provide the greatest object lesson value. (Courtesy of the LHA collection/University of Michigan.)

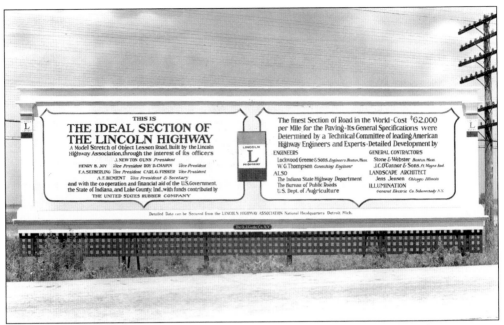

By 1920, traffic had increased on existing roads by leaps and bounds, but there were no road standards. The LHA took up the cause and used the Ideal Section as a lesson to teach state-of-the-art construction, landscape design, and lighting. The LHA erected a large billboard to promote progressive road-building techniques to travelers. (Courtesy of the LHA collection/University of Michigan.)

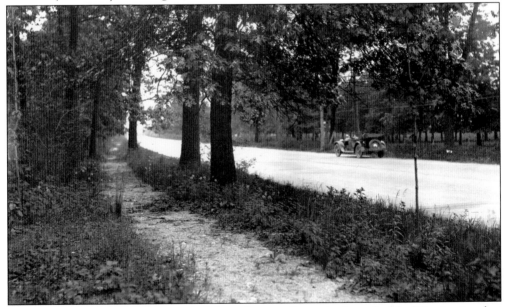

Landscape architect Jens Jensen included a pedestrian footpath along the Ideal Section in what he considered to be the showcase for a perfect highway-pedestrian corridor. The footpath was part of the effort to make highways more livable. A tree-planting program was also promoted by Jensen and taken up by the Federated Women's Club of America. (Courtesy of the LHA collection/University of Michigan.)

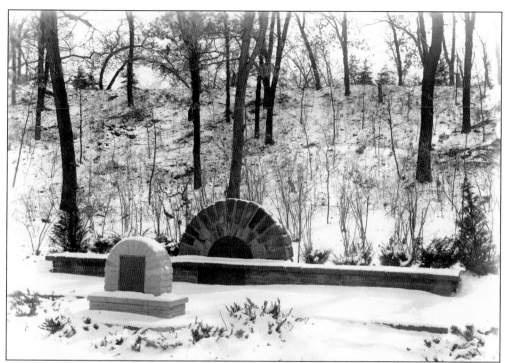

In 1926, a memorial bench was designed by Jens Jensen to harmonize with the surroundings along the Ideal Section. The prairie-style memorial bench was built to honor Henry C. Ostermann. The road in this area has changed dramatically, but the bench with its simple bronze plaque with a memorial inscription remains along a very busy section of the Lincoln Highway between Schererville and Dyer. Ostermann served the LHA as vice president and field secretary. He was born in Tell City. He died in 1920 in the prime of his life in a car accident at the age of 44 in Tama, Iowa, on the Lincoln Highway. The LHA office in Detroit was bombarded with expressions of sympathy following the accident. The LHA published a small booklet to honor his work for the Lincoln Highway. (Courtesy of the LHA collection/University of Michigan.)

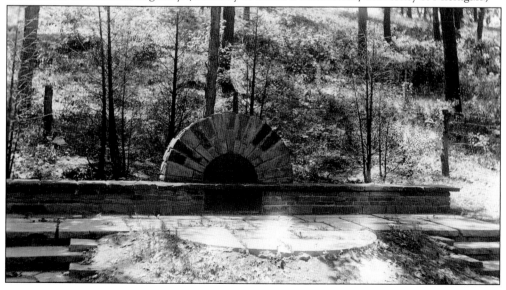

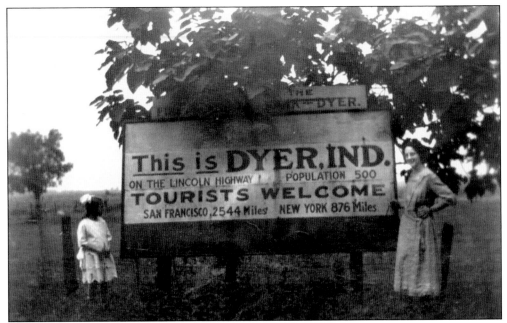

This snapshot is of the municipal sign at the Dyer city limits, taken around 1915. Travelers stop to have their photograph taken at the Dyer Lincoln Highway welcome sign. The sign is striped in red, white, and blue bands and boasts a population of 500 residents. Dyer offered few services for tourists but was the last Hoosier town along the highway as travelers drove west. Dyer is located near the Illinois-Indiana state line. (Courtesy of Russell Rein.)

Welcome signs were placed at state borders in celebration of the Abraham Lincoln bicentennial. Programs across the state are ensuring that Indiana properly celebrates the Lincoln bicentennial and honors the state's role in shaping his life. Lincoln grew up in southern Indiana from the age of 7 to 21. Welcome signs were dedicated by Gov. Mitch Daniels in 2007. This one is at Dyer on the Lincoln Highway. (Author's collection.)

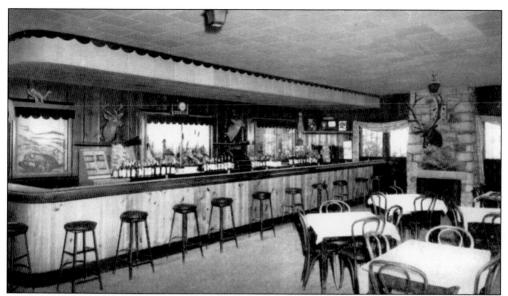

Walley's Café just west of Dyer on the Indiana-Illinois line must have been a "man's world." The interior of the café is decorated in hunting themes and provides a full board with a dozen bar stools. (Courtesy of Russell Rein.)

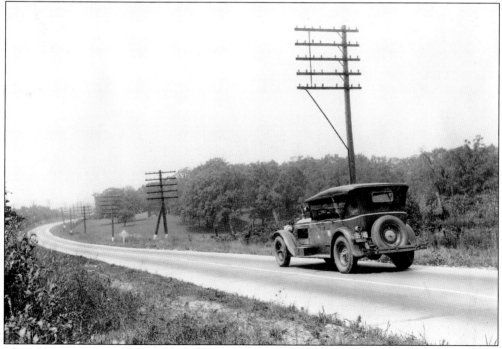

The LHA published a booklet titled *Tips for Tourists* that provided a long list of equipment travelers would need in order to successfully complete a transcontinental journey in 1915. The list must have been daunting, but many Indiana residents set out for San Francisco. Many would travel the route west and once on the coast, they would take the train back home and have their automobiles shipped home. (Courtesy of the LHA collection/University of Michigan.)

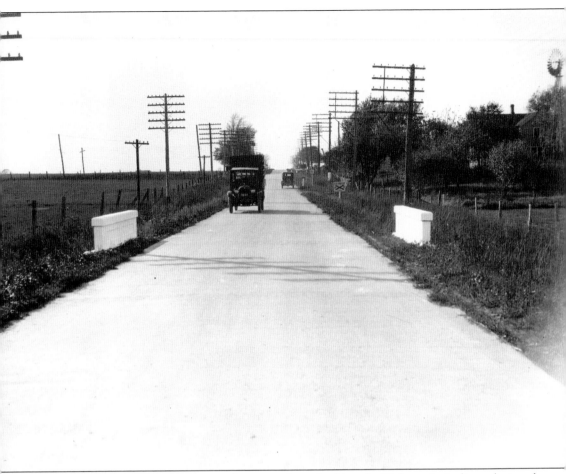

This photograph captures a typical section along the Lincoln Highway in Indiana during the mid-1920s. The mud, macadam, poor road conditions, inadequate wood and iron bridges, and most of the dangerous railroad crossings had given way to progress. The private efforts of the LHA had worked to persuade county and state officials that improved roads were in the public interest. Traveling the Lincoln was no longer difficult.

Eight

A SHORTER WAY

In the fall of 1926, Indiana newspapers announced that all state highways would be renumbered under a permanent numbering system to conform to the U.S. Bureau of Roads numbering system. East–west roads would be given even numbers and north–south roads would have odd numbers. Until this time, each state numbered the roads that ran through their state. A federal road would often change names when it crossed from one state into another. Under the federal system, the Michigan Road (later known as the Dixie Highway) became U.S. 31 and State Road 2 became U.S. 30. In October 1928, it was announced that U.S. 30 was completed across the United States and nearly all paved.

It was in this time period that the Lincoln Highway route across Indiana was shortened between Fort Wayne and Valparaiso. From the Goshen Road in Fort Wayne the road headed west of Washington Center Road on an alignment that ran through Columbia City, Warsaw, Atwood, Etna Green, Bourbon, Inwood, Plymouth, Donaldson, Grovertown, Hamlet, Hanna, and Wanatah. The shorter alignment reconnected to the original 1913 route in Valparaiso and continued as Joliet Road through Deep River, Merrillville, Schererville, and Dyer on the western border of Indiana.

In 1928, the LHA and the Boy Scouts of America teamed up to place concrete markers along the Lincoln Highway. This was the last official act of the LHA before closing its office in Detroit. The markers honored the nation's martyred president Abraham Lincoln and directed travelers around curves and critical turning points. Located along Indiana's second alignment, several original concrete markers can be found in public spaces. Look for them at the New Haven City Hall, at Vice Pres. Thomas Marshall's home in Columbia City, in Funk Park in Warsaw, at the Marshall County Historical Museum, at the La Porte County Historical Museum, and just east of the city hall in Valparaiso.

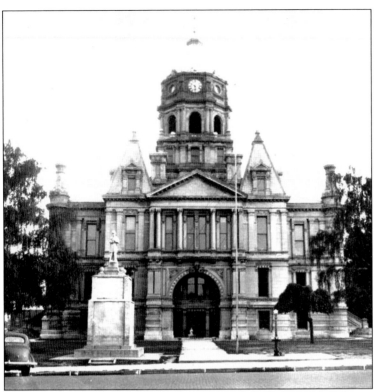

Columbia City is the county seat and boasts a beautiful courthouse designed by Fort Wayne architect Brentwood Tolan. Beginning in 1926, the Lincoln Highway entered the city on Chicago Street and then turned onto Main Street. At the courthouse square, the route turned west on Van Buren Street. This photograph captures a scene along Van Buren Street (the Lincoln Highway) in the 1920s. (Courtesy of the Whitley County Historical Society.)

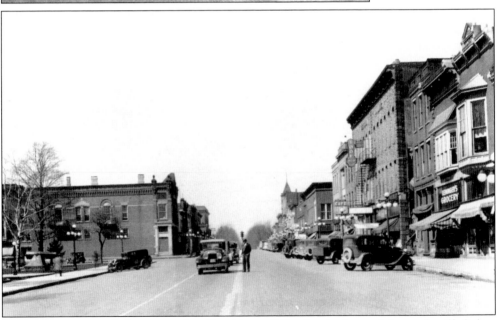

The town appears ready for increased traffic with a well-lined main thoroughfare and traffic lights. Notice the streetlight at Chauncey Street, the International Order of Odd Fellows building, the grocery store, and the cannon on the square. It was scrapped for metal during World War II. The buildings in this photograph along the courthouse square still stand. (Courtesy of the Whitley County Historical Society.)

"What this country needs is a good 5 cent cigar." Thomas Marshall made this expression famous. Marshall was born in Wabash and built his law career in Columbia City. He became vice president under Woodrow Wilson. Marshall came to Indiana to dedicate the Lincoln Highway, and it was the Frankfurt Cigar Company that manufactured the official Lincoln Highway cigar. (Author's collection.)

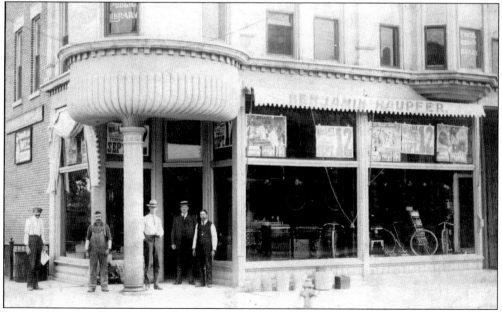

The Raupher store was located west of the Whitley County Court House on the northeast corner of Van Buren and Line Streets. The store sold a variety of goods including bicycles and appliances. The first public library in Columbia City was located on the second floor. Notice the Wallace Circus poster in the window. This building is now restored and stands in great architectural style on the Lincoln Highway. (Courtesy of the Whitley County Historical Society.)

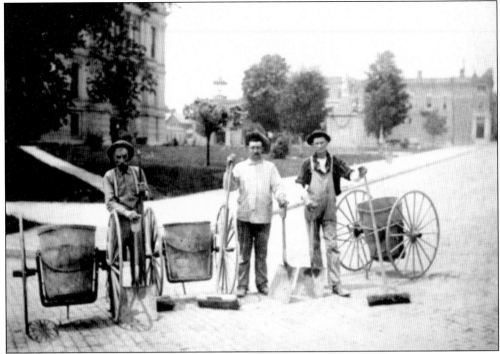

This photograph captures the street sweepers in Columbia City preparing to clean the streets. The team of sweepers is working around the Whitley County Court House Square. The equipment includes pull carts, a shovel, and a broom. This became the Lincoln Highway a few years after this photograph was taken. (Courtesy of the Whitley County Historical Society.)

In October 1931, Adm. Richard E. Byrd's 37-ton famous snow cruiser slowly made its way from Chicago to Boston to begin an expedition at the South Pole. Coming through Kosciusko County and then into Whitley County, the cruiser had problems fitting through narrow bridges. Taking two days to cross Indiana, the crew spent the night in Warsaw and was greeted with huge crowds and dinner. (Courtesy of the Whitley County Historical Society.)

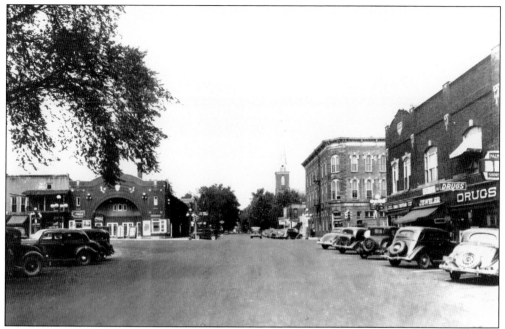

Lincoln Highway travelers followed the highway around the square in Columbia City. This photograph captures the scene going north on Main Street. A drugstore is on the right-hand side and offered a soda fountain. Five-globe lights lit the streets at night, and the Columbia Theatre provided entertainment at Main and Van Buren Streets. (Courtesy of the Whitley County Historical Society.)

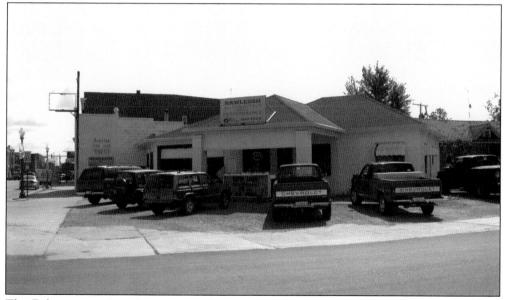

The Fisher gas station sits on an angle on the southeast corner of Van Buren and Walnut Streets in Columbia City. It was at this corner that the Lincoln Highway turned north on Walnut Street and headed out of town. The station was built in 1922 and was owned by Marion Fisher. The building is being used today as an automobile garage and oil change business. (Author's collection.)

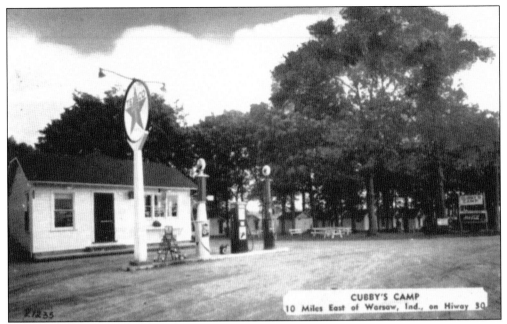

This real-photo postcard image shows Cubby's Camp in Kosciusko County. Cubby's was a one-stop. Customers could rent a small cabin complete with a picnic table and a parking spot. This small business sold Texaco gasoline, Coca-Cola, and groceries. The bungalow-style main building indicates that it was built in the 1930s. (Courtesy of Russell Rein.)

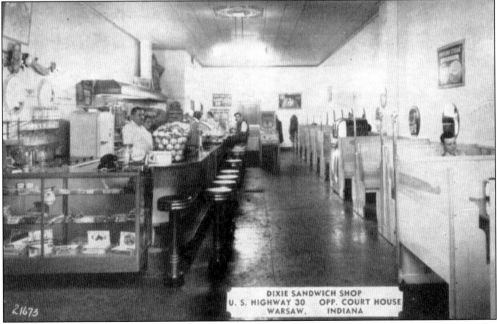

The Dixie Sandwich Shop was located on the Kosciusko County Court House Square. The restaurant is complete with a jukebox and booth seating, making it a popular place for teenagers. A pinball machine is on the far end of the shop. Cigars and gum are for sale in the glass case. (Courtesy of Russell Rein.)

MULBERRY HILL TOURIST CAMP

6 MILES EAST OF BOURBON, IND. 9 MILES WEST OF WARSAW, IND.
On Federal Road 30 (Or Lincoln Highway)
F. J. SNIDER, Proprietor
POST OFFICE ADDRESS—ETNA GREEN, INDIANA

Mulberry Hill Tourist Camp was located near Etna Green on the 1926 Lincoln Highway alignment. F. J. Snider was the proprietor. The camp advertised tourist camp rooms and sold gas, fresh eggs, and cigarettes. (Courtesy of Russell Rein.)

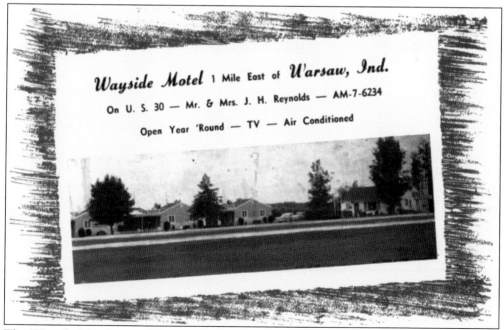

Wayside Motel 1 Mile East of *Warsaw, Ind.*
On U. S. 30 — Mr. & Mrs. J. H. Reynolds — AM-7-6234
Open Year 'Round — TV — Air Conditioned

The Wayside Motel east of Warsaw was built in the 1950s with carports connecting rental units. This was a modern-style motel with air-conditioning and heat. It was open year-round. (Courtesy of Russell Rein.)

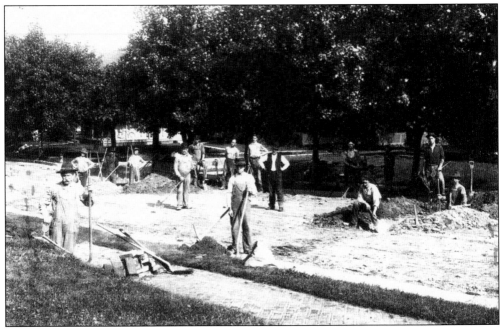

In this photograph, pavers are being laid on the new road that would become the Lincoln Highway in Bourbon on the north side of the Pennsylvania Railroad. (Courtesy of the Whitley County Court House.)

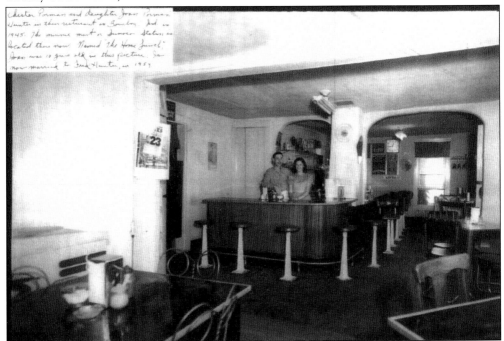

In 1945, the Home Lunch Restaurant in Bourbon was owned by Chester Porman. This photograph includes his 10-year-old daughter Joan Porman Hunter, who worked as a waitress for her father. The interior appears much like an ice-cream parlor. The site in later years became a mini-mart and then the Sunoco station. (Courtesy of the Marshall County Historical Society.)

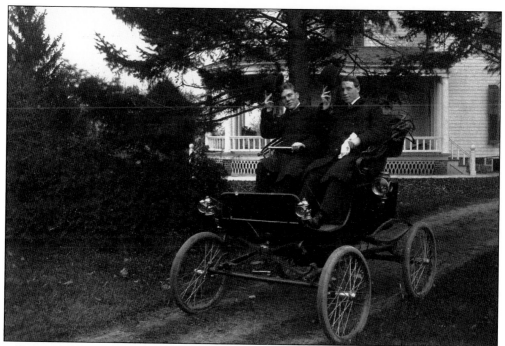

Billy Erwin (left) is "at the stick" of the first car in Bourbon, which he purchased in early April 1902 for $850. Erwin and his steam-powered Sterns are pictured in front of the Erwin house at the south end of Bourbon. Erwin was a victim of the 1918 influenza epidemic so was not a witness when the Lincoln Highway route was changed across Indiana in 1926. (Courtesy of the Marshall County Historical Society.)

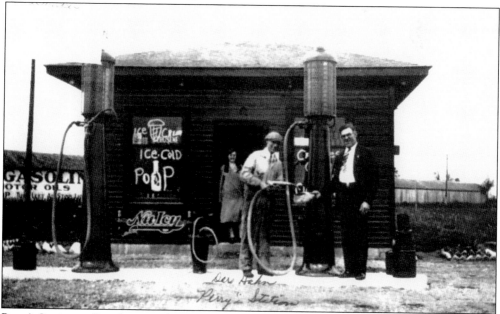

Perry's Station in Bourbon was built in 1922 by Victor Shumaker. The station had two gasoline pumps. Locals hung out to watch travelers come and go. Ice cream and pop were for sale. Darro Hahn was the attendant. (Courtesy of the Marshall County Historical Society.)

Roads turned to mud in Marshall County before the Lincoln Highway crossed the county in 1926. The State of Indiana Highway Commission was in dispute with local officials as plans were being made to shorten the route between Fort Wayne and Valparaiso. Marshall County's slow response to building a new bridge to handle the traffic over the Yellow River nearly cost Plymouth the route. At the last hour, an agreement was made causing a huge economic boon to area businesses. (Courtesy of the Marshall County Historical Society.)

Employees at the Marshall County Highway Department collected outdated road signs at their facility. They must have appreciated the changing road numbers, names, population counts, and signage styles. (Courtesy of the Marshall County Historical Society.)

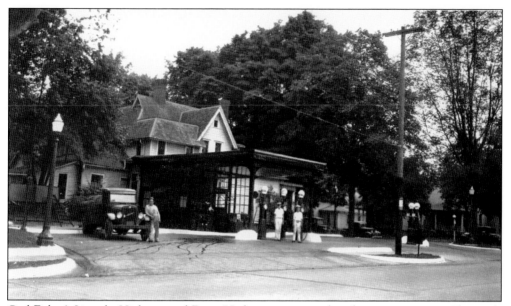

Carl Fisher's Lincoln Highway and Dixie Highway intersected at this intersection in Plymouth on the 1926 Lincoln Highway alignment across Indiana. Customers could enter from either route. A Lincoln Highway porcelain sign marks the route. A Studebaker truck is parked in the lot. (Courtesy of the Marshall County Historical Society.)

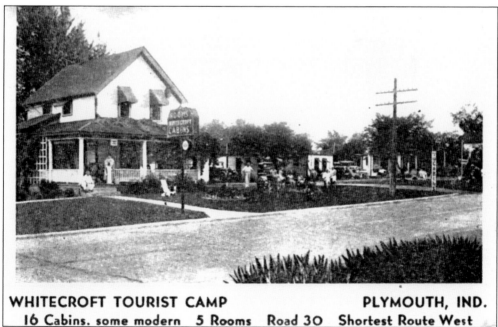

WHITECROFT TOURIST CAMP **PLYMOUTH, IND.**
16 Cabins. some modern 5 Rooms Road 30 Shortest Route West

The Whitecroft Tourist Camp was located west of Plymouth at 1409 West Jefferson Street (Lincoln Highway). At its peak in the 1930s, the camp included 16 cabins. This real-photo postcard emphasizes that this route was the "shortest route west." (Courtesy of the Marshall County Historical Society.)

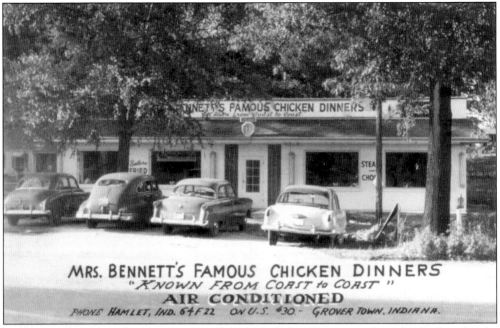

In 1946, Carl and Rose Bennett purchased the Railside Inn Restaurant from the Carlson family. In the 1950s, Mrs. Bennett's Railside Inn served chicken dinners for $1.25. The clock on the exterior of the building reminded customers that it was time to eat. Coca-Cola products were advertised. (Courtesy of the Marshall County Historical Society.)

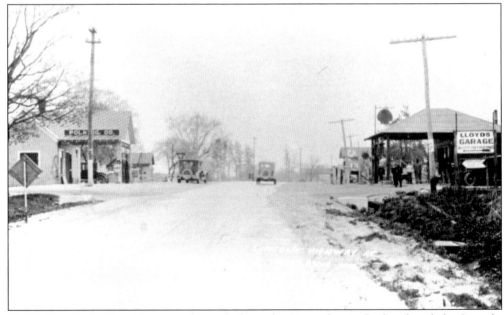

Lloyd's Garage in Donaldson was located along the Pennsylvania Railroad and the Lincoln Highway. The road and railroad ran parallel to each other following an east–west course. This photograph shows Lloyd's Garage and Auto Repair Station in the 1920s. The Polk Oil Company sold gas under a canopy-style station with twin pumps. Customers could pump air for their tires or get oil for their engines. (Courtesy of the Marshall County Historical Society.)

Nine

THE LINCOLN HIGHWAY IN INDIANA TODAY

The Detroit office of the LHA released a newssheet in 1915 that read, "These Hoosiers get things done." The leadership of the association was referring to the rate that Indiana's cities, towns, and counties improved their roads. Automobiles and roads were one enterprise in the Hoosier state and both became part of Hoosier pride and culture.

Time marches on but some things have not really changed much. The membership of the Indiana Lincoln Highway Association (INLHA) has a new vision for what the historic corridor means to the state of Indiana and to its neighboring states of Illinois and Ohio. INLHA members are active in preservation and promotion efforts across the state. Thirty volunteers were trained by the Historic Landmarks Foundation of Indiana to undertake a historic sites survey in 2007. Team members began documenting locations of tourist cabins, gas stations, camps, motels, road alignments, bridges, and other sites related to the automotive and travel history across Indiana's Lincoln Highway. The team took digital photographs and GPS readings in hopes that more sites can be saved across the state.

The association has been raising funds to complete the survey and place interpretive kiosks at locations along both of Indiana's Lincoln Highway alignments and has applied for a state byway designation. The group also formed an education committee to write a Lincoln Highway curriculum for school students and has produced a DVD on the Lincoln Highway for the project. The INLHA became an affiliate of the Historic Landmarks Foundation of Indiana in 2008 and opened an office in South Bend as a base for the organization's activities. The office is located at 402 West Washington Street. The Hoosiers, they get things done.

In 1992, the LHA was reestablished with the mission to preserve and promote the Lincoln Highway across the United States. Each year the LHA holds an annual conference to share information and explore the highway. This group of LHA members with ties to Indiana poses to have a snapshot taken at the 2007 conference at a drive-in in Fort Morgan, Colorado. (Courtesy of Mike Kelley.)

This 1926 Lincoln Highway alignment may be meeting the fate of other Indiana alignments. One property owner wishes to close this section for private use while neighbors wish to keep access to their property. The dispute has been brought before the Whitley County commissioners, who are struggling to determine who actually owns this section of the 1926 route. (Author's collection.)

In 1928, landscape architect Jens Jensen designed memorial markers for the LHA. Approximately 2,436 markers were placed by the Boy Scouts to honor Abraham Lincoln. The markers were made of reinforced concrete with a Lincoln Highway logo, a cast bronze medallion, and directional arrows. This marker stands with a new Lincoln Highway monument and a Sauk Trail monument in Valparaiso. (Author's collection.)

The Anthony Wayne Council of the Boy Scouts of America placed signs along the Lincoln Highway and the monument in Funk Park in Warsaw as part of the 75th anniversary of the placing of markers by the Boy Scouts in 1928. This site is along the 1926 Lincoln Highway route across Indiana. A meeting is held each September at Funk Park to conduct an inventory of the signs and to call the public's attention to the highway as a memorial to Abraham Lincoln. (Courtesy of Joyce Chambers.)

On the east side of Columbia City, a set of five tourist cabins offered overnight shelter along the Lincoln Highway route that carried the name Chicago Street east of downtown. The cabins stood along the Pennsylvania Railroad line at the Log Cabin Camp. Instead of numbers, the cabins were given a name of a planet. Four of the cabins were moved to Tri Lakes where three of them survive. (Courtesy of the Whitley County Historical Society.)

This kiosk was funded by the Kosciusko County Historical Society and the LHA. The kiosk is located at Chinworth Bridge Trailhead, just west of the city of Warsaw along the Lincoln Highway. The INLHA was a partner in obtaining the funding for this project. (Author's collection.)

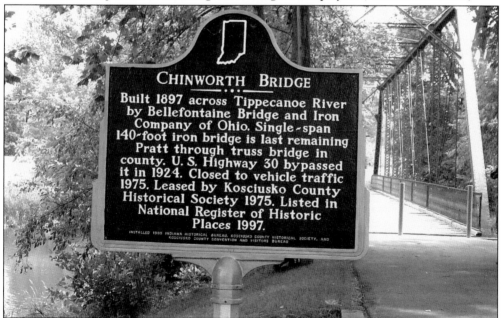

The Chinworth Bridge Trail is approximately two miles long and connects the City-County Athletic Complex to the west side of Warsaw along the 1926 Lincoln Highway route. The trail begins along the Tippecanoe River at the trailhead parking lot located on old U.S. 30 West. This site includes the restored iron-truss bridge, a picnic shelter, a Lincoln Highway interpretive kiosk, and a canoe launch. (Courtesy of Joyce Chambers.)

In 2007, local Goshen resident Tom Riggs headed up a project to place 54 Lincoln Highway signs along the original route of the Lincoln Highway through the city of Goshen. The project was spearheaded by the INLHA and the Goshen Street Department, which made and installed the three-color signs. (Author's collection.)

Bill Binder of South Bend is a member of the Studebaker Driver's Club. He is standing next to his 1951 Studebaker Champion at a car show celebrating the Lincoln Highway in 2007 at the Marshall County Historical Society in Plymouth. Binder has restored this vehicle, which is known for its bullet-nose design. The car was built in South Bend. (Author's collection.)

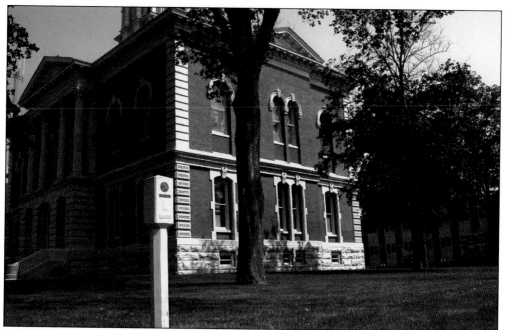

Built in 1872, the Marshall County Court House is located at 117 West Jefferson Street on the Lincoln Highway. The building was designed by G. P. Randall in the Italian villa style. The Marshall County Boy Scouts and Hoosier Old Wheels purchased a 1928 reproduction Lincoln Highway marker to place on the south lawn. The Scouts also placed Lincoln Highway signs on the route through the county. (Author's collection.)

The Hemminger Home served travelers on the 1926 route for many years. Recently restored by the Wythougan Preservation Council, the building is now a shelter for women. A Lincoln Highway pillar was placed in the front yard to honor its connection to the Lincoln Highway heritage and its national register status. (Courtesy of Kurt Garner.)

Located at 607 Lincolnway in downtown La Porte, B&J's American Cafe is a visit back in time. Americana surrounds customers, and the owner will sell a book on the Lincoln Highway or another nostalgic volume. This is a gathering place for the community and a refreshing stop for tourists. (Author's collection.)

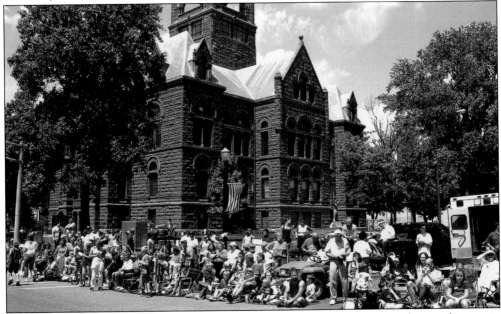

The Fourth of July is an extraordinary event in the city of La Porte. Sixty thousand patriotic citizens begin to line up 24 hours in advance of the parade. Local ordinance allows parade-goers to mark spots with blankets or chairs. This photograph captures parade-goers in front of B&J's American Cafe. (Author's collection.)

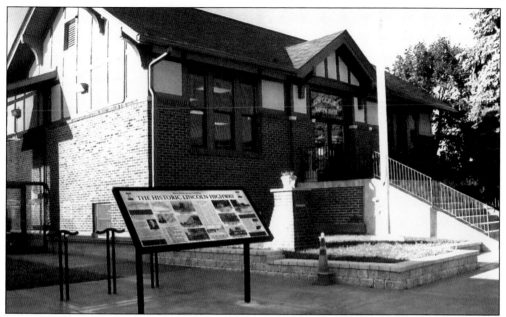

A kiosk was placed at the town hall in New Carlisle on October 18, 2008, to celebrate the Lincoln Highway. The Town of New Carlisle, Historic New Carlisle, the LHA, and the INLHA worked together to design, fund, and place the kiosk. (Author's collection.)

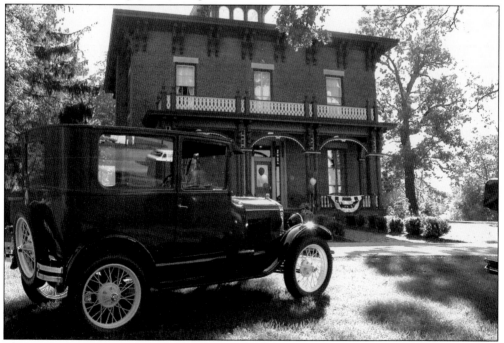

The Inn at the Old Republic is owned by Historic New Carlisle and serves as a bed-and-breakfast as well as a museum for New Carlisle and Hudson Lake. This grand Italianate home stands on the hill above the Lincoln Highway. A 1927 Model T owned by Bill Woodke of La Porte is parked on the lawn in celebration of Lincoln Highway Day in New Carlisle in 2008. (Author's collection.)

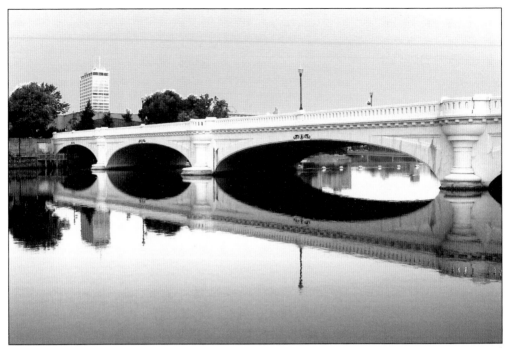

The Jefferson Street bridge—a Lincoln Highway feeder—in South Bend has been fully restored by the Indiana Historic Spans Task Force for its 100th birthday. The beautiful concrete arch span bridge won the 2007 National Preservation Honor Award. Its graceful lines and classical details have reemerged in steel and concrete. (Courtesy of Greg Koehler.)

This intersection in downtown South Bend is the crossing point of the Lincoln and Dixie Highways. This intersection is marked as Michigan and Washington Streets. From left to right, Bill Arick, Mikki Dobski, Joyce Chambers, and Bev Gillespie meet to discuss the placement of historical markers and banners at the Dixie and the Lincoln Highways. (Author's collection.)

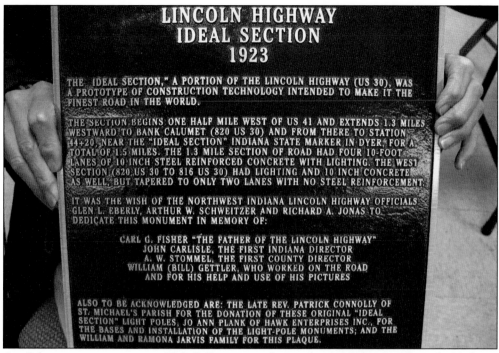

LINCOLN HIGHWAY
IDEAL SECTION
1923

THE IDEAL SECTION," A PORTION OF THE LINCOLN HIGHWAY (US 30), WAS A PROTOTYPE OF CONSTRUCTION TECHNOLOGY INTENDED TO MAKE IT THE FINEST ROAD IN THE WORLD.

THE SECTION BEGINS ONE HALF MILE WEST OF US 41 AND EXTENDS 1.3 MILES WESTWARD TO BANK CALUMET (820 US 30) AND FROM THERE TO STATION 44+20 NEAR THE "IDEAL SECTION" INDIANA STATE MARKER IN DYER, FOR A TOTAL OF 1.5 MILES. THE 1.3 MILE SECTION OF ROAD HAD FOUR 10-FOOT LANES OF 10-INCH STEEL REINFORCED CONCRETE WITH LIGHTING. THE WEST SECTION (820 US 30 TO 816 US 30) HAD LIGHTING AND 10-INCH CONCRETE AS WELL, BUT TAPERED TO ONLY TWO LANES WITH NO STEEL REINFORCEMENT.

IT WAS THE WISH OF THE NORTHWEST INDIANA LINCOLN HIGHWAY OFFICIALS GLEN L. EBERLY, ARTHUR W. SCHWEITZER AND RICHARD A. JONAS TO DEDICATE THIS MONUMENT IN MEMORY OF:

CARL G. FISHER "THE FATHER OF THE LINCOLN HIGHWAY"
JOHN CARLISLE, THE FIRST INDIANA DIRECTOR
A. W. STOMMEL, THE FIRST COUNTY DIRECTOR
WILLIAM (BILL) GETTLER, WHO WORKED ON THE ROAD
AND FOR HIS HELP AND USE OF HIS PICTURES

ALSO TO BE ACKNOWLEDGED ARE: THE LATE REV. PATRICK CONNOLLY OF ST. MICHAEL'S PARISH FOR THE DONATION OF THESE ORIGINAL "IDEAL SECTION" LIGHT POLES, JO ANN PLANK OF HAWK ENTERPRISES INC., FOR THE BASES AND INSTALLATION OF THE LIGHT-POLE MONUMENTS; AND THE WILLIAM AND RAMONA JARVIS FAMILY FOR THIS PLAQUE.

Art Schweitzer greets guests at Teibel's Restaurant during the Art Schweitzer Lincoln Highway Day in Schererville in April 2008. Schweitzer has worked for decades to preserve the history of the Ideal Section on the Lincoln Highway between Dyer and Schererville. The Ideal Section was built in Lake County to educate people about how good roads could be constructed. The demonstration section was complete with safety features, lighting, drainage, and a pedestrian footpath. Schweitzer had plaques made that he hopes one day will be mounted on either end of the Ideal Section along with the restored Ideal Section streetlights built by General Electric. Currently the plaques are housed at the Schererville Historical Society until permission is granted by local and state officials to place them along the road. The INLHA's Lincoln Highway Day luncheon honored Schweitzer with a proclamation and a porcelain Lincoln Highway sign. (Author's collection.)

The Indiana Abraham Lincoln Bicentennial Commission awarded grant funds to the INLHA to create and hang street banners along the original 1913 route. The commission has also provided funding to print Lincoln Highway brochures and funds to design and cast a bronze marker to be placed at the intersection of the 1913 alignments of the Lincoln and Dixie Highways in South Bend in June 2009. (Courtesy of the INLHA.)

For nearly 100 years, the Lincoln Highway has stretched across northern Indiana. It has linked Hoosiers to New York and San Francisco and has brought travelers from the east and west. Today the route provides evidence of Indiana's history and retains significant architecture, landmarks, and unique glimpses back in time. Its historical importance brings increased tourism, economic development, and new interest in preserving roadside structures along its path. Communities touched by the Lincoln Highway invite travelers to discover the varied and rich cultures that can be found along this historic two-lane highway that was once the nation's first transcontinental automobile road. The legacy of the nation's first memorial to Abraham Lincoln continues to be a vital part of Indiana heritage. Take a ride along the Lincoln Highway—the road dedicated to the nation's 16th president. The road is waiting. For more information about the Lincoln Highway in Indiana, visit the INLHA Web site. (Author's collection.)

BIBLIOGRAPHY

Carter, Anne Bryan, ed. *Painting Indiana: Portraits of Indiana's 92 Counties*. Bloomington: Indiana University Press, 2000.

A Complete Official Road Guide of the Lincoln Highway. 5th ed. Detroit: Lincoln Highway Association, 1924.

Davies, Pete. *American Road: The Story of an Epic Transcontinental Journey at the Dawn of the Motor Age*. New York: Henry Holt and Company, 2002.

Fisher, Jane Watts. *Fabulous Hoosier: A Story of American Achievement, by Jane Fisher*. New York: R. M. McBride and Company, 1947.

Fisher, Jerry M. *The Pacesetter: The Untold Story of Carl G. Fisher*. Fort Bragg, CA: Lost Coast Press, 1998.

Goshen: The First 150 Years 1831–1981. Goshen, IN: News Print Company, 1981.

H. C. Ostermann. Lincoln Highway Association.

Horvath, Dennis, and Terri Horvath. *Indiana Cars: A History of the Automobile in Indiana*. Indianapolis: Hoosier Auto Show and Swap Meet, 2002.

Lincoln Highway Association. *The Lincoln Highway: The Story of a Crusade That Made Transportation History*. New York: Dodd, Mead and Company, 1935.

Nissley, D. Lowell. *The Road My Father Traveled*. Sarasota, FL: Robert B. Abel, 2006.

Royse, Honorable L. W. *A Standard History of Kosciusko County Indiana*. Chicago: Lewis Publishing Company, 1919.

South Bend and the Men Who Made It. South Bend, IN: Tribune Printing Company, 1901.

State Highway Commission. *Highways of Indiana*. Indianapolis: State Highway Commission 1948.

Whitley County Historical Society. *Whitley County and Its Families: 1835–1995*. Paducah, KY: Turner Publishing Company, 1995.

DISCOVER THOUSANDS OF LOCAL HISTORY BOOKS FEATURING MILLIONS OF VINTAGE IMAGES

Arcadia Publishing, the leading local history publisher in the United States, is committed to making history accessible and meaningful through publishing books that celebrate and preserve the heritage of America's people and places.

Find more books like this at
www.arcadiapublishing.com

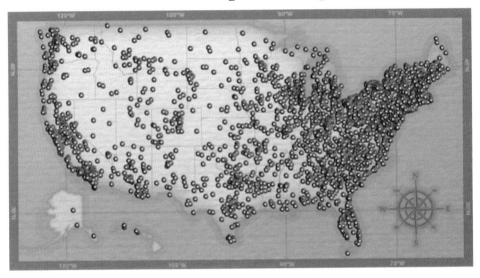

Search for your hometown history, your old stomping grounds, and even your favorite sports team.

Consistent with our mission to preserve history on a local level, this book was printed in South Carolina on American-made paper and manufactured entirely in the United States. Products carrying the accredited Forest Stewardship Council (FSC) label are printed on 100 percent FSC-certified paper.

MADE IN THE